JANET LEACH
potter

JANET
LEACH
potter

JOANNA WASON

With a foreword by David Whiting

UNICORN

This new edition published in 2024 by
Unicorn, an imprint of Unicorn Publishing Group
Charleston Studio
Meadow Business Centre
Lewes BN8 5RW
www.unicornpublishing.org

First edition published by Worldaway 2021

ISBN 978 1 916846 00 5
10 9 8 7 6 5 4 3 2 1

Design by newtonworks.uk
Printed in Turkey by Fine Tone Ltd

Front cover image: Janet in Tamba, Japan; late 1960s; photographer
unknown

Endpaper image: Detail of Stoneware charger, brown body with white
and brown trailed glazes, diameter 48cm, *c.* 1970. Image courtesy of
Maak Contemporary Ceramics

Contents

Foreword

Janet Darnell Leach was one of the most distinguished figures in twentieth-century British pottery, and a complete one-off, both in terms of her work and her vivid personality. Few Western potters used the wheel and kiln so expressively, exploring the full potential of generously used clays and glazes. I always think of Janet as the potter who exemplified more than any other the particular abstract spirit of St Ives, from the 1950s onwards. She fully understood both the painterly and sculptural nature of what she was doing, not only how it related back to her sculptural experience in New York in the 1940s, but to the gestural materiality of the best contemporary abstraction in Europe and the USA. Janet's approach to making pots was bold and broadside and quite unlike any other, least of all the generally softer, more restrained and lyrical qualities of the Leach school.

Janet's art had a gutsier elemental ambition, but it possessed great sensitivity too, a real understanding of the pulse of freed up throwing, of robust slab-work and press-moulding, the way a pot could be energised by rhythmical pourings of glaze, the textures and imprints made by hands, tools and firing. I know Janet would prefer us to think of 'expressiveness' rather than self-expression. She was not concerned with the limitations of having something 'personal' to say, of the individual utterance, any more than she liked those attention-seeking aspects of the craft and art scene. Her work belonged to a broader world, just as Janet did herself. Her artistic outlook was international, her pots convincingly modernist. Some European potters now looking to Japan make pastiche versions of Far Eastern work (often excessively co-opting the parlance of its culture). Janet's pots were a much more effective synthesis of East–West ideas of form and surface. She fully understood the lessons of Japanese kiln traditions, and so was able to make something markedly different. I think her ambition owes much to her American roots too, looking back across the Atlantic. She was a pioneer wood-firer here before it became so seductively voguish, her flame-affected pots possessing a greater finesse and character than many in this idiom do. She was one of the few to treat porcelain as expansively as stoneware.

A complex woman, she combined high intelligence with deep common sense (her eloquence demonstrated in her excellent writings on pottery). She was disarmingly forthright and honest, and saw through any pretence and posturing. In the end it was her open-heartedness that many will remember

most, both in her work, and the kindness, support and loyalty she showed to others. The potter Joanna Wason was one of these. Janet's personal assistant at the Leach Pottery (where she originally trained) and a good friend for many years, Joanna has more than returned this affection in this warm and perceptive portrait of a great potter. St Ives still feels diminished without her.

David Whiting

Janet with some of her pots

Preface

Not long before she died, Janet told me she had been approached for her consent and cooperation in the creation of a biography, while at the same time a publisher had asked her for an autobiography. She had refused them both, explaining that ever since Bernard died she had been interviewed so often about him, that when it came to herself she just couldn't face it, preferring to spend whatever time she had left living her life and working, not dwelling on the past.

For nearly ten years I worked for Janet, assisting in her workshop and, among other things, writing out her letters for her by hand. Her stories of growing up in Texas, followed by going to work in New York as a teenager in the 1930s struck me as remarkably impressive and often highly entertaining, so when she told me about turning down the biographies, my immediate response was that I might write about her myself. Until then it had in fact never crossed my mind. She said, 'That would be interesting.'

Janet knew she was approaching the end of her life, and in the light of our conversation and having no immediate family of her own, during the following days she gathered up and handed me several folders containing notebooks, diaries and letters, as well as boxes of photographic negatives from photographs she had taken in Japan, and even some early family photographs. Among her letters were those that she had written to Bernard from Japan in 1954 and 1955, all of them annotated and dated in pencil by him, but there were only a few of Bernard's letters to her, so the correspondence between them, that remained in her possession, was almost but not exclusively one-sided.

Joanna Wason
St Just

Introduction

Thirteen years after Janet died I curated an exhibition of her work which opened at the Leach Pottery in April 2010. The wall texts outlining the events of her life were largely derived from her own writings which I had transcribed from her almost indecipherable handwritten notebooks and diaries, which having worked with her for so long, I was just able to read. All the following quotes of Janet's recording her early experiences in Texas, are from her notebooks. Quotes from her final months in New York and first few months in Japan are taken from her diaries and letters.

Aware that Janet was frequently underestimated, overshadowed by Bernard's formidable reputation, I felt she was due an excellent exhibition, showing the best examples of her work and presenting the trajectory of her life in all its colour. At first, in my hunt for pots, I contacted museums, galleries and individuals from all over Britain, but was offered so many fine examples that in the end all but a few of the sixty pots that were exhibited came from private collections within twelve miles of the Leach Pottery.

The collectors I approached supported the project with great generosity. Many had known Janet personally and had warm memories of time spent in her company. They offered such a wealth of top-quality work to show that even though I had chosen them myself, I was not truly prepared for the impact of seeing the final selection all displayed together. Some of their pots I had known before and some were new to me. I was delighted by the enthusiastic public response to the exhibition. Many visitors expressed their surprise to discover Janet as such a serious and unique potter in her own right, and as someone with such tenacity and charm.

It was clear that while Janet was known as Bernard's wife, who ran the Leach workshop and made her own pots in St Ives, much less was generally known about her origins in Texas, or her time as a young woman in New York and Japan. I want to throw more light on these earlier years of her life, which were fundamental in making her the mighty character she was and in setting her on her single-minded course as a potter. Many visitors reading the wall texts in Janet's exhibition said they would like to see her extraordinary story expanded into a book, and it seems an auspicious time to start now, this year being the centenary of her birth.

December 2018

CHAPTER 1 Early Years in Texas

Janet was born in Texas on 15 March 1918, the only child of Walter and Ollie Darnell. Fifty years earlier her maternal great grandparents, the Darbys, had travelled six hundred miles in covered wagons from Missouri to East Texas where they finally stopped, five miles outside Grand Saline. There they built a clapboard house from hand-hewn timber and established a small farmstead. Janet's grandfather, John Darby, was twelve when he made this journey with his extended family. His grandmother was said to have covered almost the entire journey on foot, driving a pair of yoked oxen before her.

Janet's great grandparents on her father's side were also farmers who had joined the great migration to Texas after the Civil War. Unwittingly all her pioneering forbears had settled in an area of relatively poor soil, midway between fertile farmland on one side and the spectacularly productive East Texas oil fields which lay, as yet undisturbed, fifteen miles away on the other. Janet wrote, 'It seems that oil forms only around the edge of salt domes and we were sitting right on top of one.'

Generations of Caddo and Cherokee traders had worked the land close to Grand Saline, collecting and dealing in crystal salt evaporated from the surface brine streams and salt water springs and swamps of the area's salt prairies. They were eventually forced off the land during the prolonged and many-faceted extermination of Native American tribal culture. Gradually European settlers moved in and established Grand Saline as a salt-mining town.

Clearly a salt pan was not ideal farming country. As Janet said, 'I have always maintained our family was born to work hard for a living. Why anyone would travel from Missouri and stop there, I could not figure. It was deep sand, small trees, low brush ... no river in miles.' Growing up in this demanding environment must have contributed to the determination and resilience which Janet evidently developed early and went on to demonstrate all her life. She described the difficult farming conditions faced by both sides of her family as 'about the only thing the families had in common.' In temperament the Darbys and the Darnells could not have been more different.

Janet's paternal grandparents moved away from their farm to find work in Dallas, about seventy miles west of Grand Saline. Her mother's family remained in the area on their farm, so the Darbys and the Darnells saw much less of each other, but Janet said that until then, 'my poor mother, of the Darby

Janet's parents, Walter and Ollie Darnell, Grand Saline

tribe, fought to raise me by rigid Darby standards while I was being subjected to the happy ways of the Darnells, a big family who all loved cards and dominoes.' There was always laughter and joking when the Darnells were around. They were 'happy rolling stones with a love for everyone'.

The Darbys

In contrast to the easy-going Darnells, the Darbys grew up under the watchful eye of John Darby, a strict disciplinarian who would not tolerate any type of frivolity or laughter. He was a book-keeper at the Grand Saline cotton gin, where fibre from the local cotton crop was mechanically separated from the seeds. His ten children were kept in check by 'the liberal use of his belt'. According to Janet he was 'a hard, fanatical Methodist lay-preacher. They say his talks drug on longer than the preacher's sermons. One of his preaching points was that the evil in the world was done at night. He wanted a national curfew at eight o'clock'. Janet said, 'he never smoked, drank, cursed, played cards or used hot water', and she remembered his proud declaration that 'no one in my family ever chewed tobacco or dipped snuff'.

John Darby's only book was the Bible, and although he did read the local newspaper, he wouldn't allow novels in his house, regarding them as the work of the devil. He warned his family to be ever vigilant against sin, and forbade his sons from driving the wagon to dances at the weekend. He was quoted as saying, 'The horse has worked all day, he doesn't want to dance'. Janet said he

was tight with his money, and to cap it all no one could think of a single act of Christian charity from him.

Meanwhile his large family ran the farm as self-sufficiently as possible. They grew cotton as a cash crop, and corn, vegetables, peanuts and peaches for their own provisions. There were two dairy cows, a draught horse, pigs, hens, and geese for their down to fill pillows and quilts. The last of the geese was killed, plucked, and eaten, never to be replaced, when the last of the daughters, Janet's mother Ollie, married Walter Darnell, and with great relief moved away from her father's house with her new feather bedding.

The women of the house were seamstresses and quilters, providing clothes and bedding for the family, and earning an income from local customers. During her childhood visits to the farm Janet watched everything eagle-eyed, and took part in all the domestic industry from a very young age. She was happy to wring the necks of fattened pullets, quickly and cleanly for a family meal of fried chicken, and was equally comfortable plucking the geese. She said, 'Mother was always amazed that I enjoyed the farm and its activities. She had spent her youth longing to get away from it to the world of hot running water and flush toilets and she certainly wasn't going to get covered in shit from plucking live geese.'

As most of the activity around the Darby household centred on the production and preservation of food, much of the indoor space was taken up by pickling jars, and drying frames for fruit, vegetables and beans to store for

The Darby farmhouse
John and Amanda Darby with four of their children.
Janet's mother Ollie in the dark neck ribbon

the winter. Janet's grandmother Amanda sold the butter she made in a salt-glazed, stoneware churn which stood outside on the back porch.

Amanda Darby thought every girl should be able to crochet and embroider, and ought to have made at least one quilt by the age of twelve, always hand-stitched to keep it soft and supple. Years later Janet wrote, 'I still shudder when I see the unenlightened using a sewing machine to make a quilt.' There was a quilting frame in the Darbys' house, which Janet first used to make a simple quilt with four-inch squares, later graduating to a more complicated design with small diamond-shaped pieces forming a five-pointed Lone Star. Over time she became a highly accomplished seamstress.

Outside the back door was a well, with a bucket, wash pan, soap, and a dipper made from a gourd cut to the shape of a ladle. Early on Saturday mornings, during the summer months, one of the men would draw water from the well to fill tin tubs which were left outside in the sun to heat up for the traditional Saturday baths. Janet said, 'This was outdoors, I don't know how or when or even if they bothered in the winter, I know I was always called into the house when the men were bathing.'

In spite of her grandfather's forbidding nature Janet was enthralled by the Darby farmhouse, observing its contents in great detail. There were six rooms with one or two beds in all of them except the kitchen, where the family had their meals. A wide hallway went down the middle of the house with screen doors at either end to let the breezes through. Janet described the kitchen as the 'most exciting room', with its black cast-iron wood-burning stove and homemade ladder-back chairs with plaited rawhide seats. The table was scrubbed with lye soap and sand, which brought out the silver grain of the wood. The legs of the metal food safe stood in four saucers of water to keep ants out. Janet said that it was on opening this six-foot-high food safe, perforated with pineapple-shaped ventilation holes punched through, and left jagged on the outside to deter flying insects, that she first consciously recognised 'beauty through function'. Years later she said, 'I'm sure I developed my love of crafts from this house.'

The few possessions the Darbys owned which they had not made themselves came

John Darby

from a vendor who travelled through the countryside with his wagon, carrying a huge assortment of household items and farm equipment, furniture, pans, coops, fruit, anything. No money changed hands, trade was all done by barter. Janet's grandparents gave a calf in exchange for a seven-day chiming clock. The animals the vendor acquired were tethered to the wagon and walked behind. He was fed and put up for the night if necessary. His visits were of course a fertile source of news.

After Amanda died, John Darby moved all the family possessions into one room of the farmhouse for storage, and at the age of seventy-four left it all behind and went to live with his children, staying with them in turn. He rented the house out to a farming family, but to Janet's dismay it was burnt to the ground. She wondered if the mud and wattle chimney had been left unswept. Whatever the cause of the fire, the house and all its contents were completely destroyed. The item her grandfather regretted losing the most was a trunk holding a Bible containing the family tree and other personal records. He knew his family had travelled to Missouri from Tennessee but did not know where they had landed when they first arrived in America, nor where they had sailed from. The details of his family's migrations had become more important to him as he aged, and were now abruptly and irretrievably lost.

The Darnells

Soon after Janet was born, her father Walter was drafted into the Navy, the United States having become involved in the First World War the previous year. After the war Walter returned to do various casual jobs in Grand Saline until 1922, when Janet was four years old and the family left Grand Saline to move in with Walter's parents in Dallas where they had rented a fine old town house. In Dallas Walter studied accountancy, to qualify for book-keeping work with Mobil Oil in the city. Janet's aunts and uncles moved in to join them all in this large house. With her appreciative eye for detail Janet also found the Dallas house 'very exciting'. She said, 'The interior was all stained oak and flowered wallpaper. The doors were huge, some were double, some with leaded stained-glass inserts. There were two storeys plus attics, with a huge hallway and stairs. There were gas heaters in the tile-decorated fireplaces in every room. The cook stove was gas and there was a gas water heater over the bathtub. There was a flush toilet.

'This was 1922, the days of Prohibition, with flappers and short hair, the Charleston ... exciting times. Nine of us lived there and it was always buzzing. They were all working, with secure futures ahead. Some had lived through extreme hardship but this was the Roaring Twenties and Dallas was booming.'

Grandmother Darnell was a dressmaker, with 'the only hemstitching machine in Dallas'. Her shop was in a prime location on Main Street, above Woolworths and right across the road from the cinema. Janet pointed out with great pride that her grandmother could alter anything, or make perfect copies of dresses that customers took her to see in the department stores, but her dresses were always unique because the fabric was hand-picked by the customer, and she could adapt the styles to make new designs if needed. Janet worked with her, helping with the fine needlework, and said, 'It's amazing how much I learned about sewing from watching her all those years, doing lace insets in thick satin and lots of concealed hems on delicate materials. I loved it and would do it patiently for hours ... Grandmother's shop closed at six, then she came home and cooked supper for us all. It was her kitchen and her pleasure.'

When Janet was born her grandmother was still relatively young, only forty years old, and very good company. Janet said, 'Grandmother took me to the park on nice cool summer evenings and she would go on the swings with me, and actually on the slides if there wasn't anyone around. She was my only playmate.' As Janet got older her grandmother took her to see Rudolph Valentino films across the road from her shop, whereas 'Mother and Dad only took me to Rin Tin Tin.'

Janet described her Darnell grandparents as 'a perfect match in temperament ... they were both hardworking and generous to a fault. When they were young farmers they used to put the sleeping babies in the back of the wagon on Saturdays and drive for miles to go to a barn dance.'

Janet's mother acquired a huge, elaborate upright piano with intricate fretwork over a backing of dark red velvet. To quote Janet, 'It was a monster, it looked like it came from a whore house.' Ollie did not play the piano herself but was very keen for Janet to learn to play and to sing, but Janet said, 'my musical abilities proved to be non-existent. I never had a voice even before the cigarettes and whisky got to it. My heart goes out to the numerous piano teachers I had, none of them was able to instil in me the concept of rhythm but nevertheless these weekly lessons went on determinedly until the finances got tight.' In spite of this Janet always loved music and listened with delight to the latest dance records her aunt played on her Victrola gramophone.

Janet described her grandfather John Darnell as 'a huge, hearty, jolly man, just the opposite of the Darbys ... He never lent money, if someone was in trouble he gave.' Like the Darbys, the Darnells had been farmers with a smallholding near Grand Saline, but later on when they moved to Dallas John Darnell found work first in a drug store serving soft drinks, then as a

bartender, until the introduction of Prohibition, whereupon he joined the local police force. He became the first plain-clothed policeman in Dallas, driving an unmarked patrol car as 'an experiment in crime control'. Eventually he was promoted to the rank of sergeant. Janet enjoyed some real excitement when, on night duty, he took her to the Texas State Fair in Dallas, amid the bright lights, and put her on every ride. A hot shot on the rifle range, she proudly returned home carrying a toy she had won herself, 'as well as whistles, feathers and junk'. When she was a little older her grandfather gave her a pair of roller skates which she found hard to

Janet's paternal grandfather John Darnell, in police uniform

manage, but later on, to her great joy, he gave her a bicycle, allowing her some freedom of movement for the first time.

One day he gave Janet 'a very elegant switchblade knife … and then the gorgeous array of knives kept on coming in'. These had been dropped on the floor of the police van, or confiscated from suspects as they were brought into police custody, and through them Janet discovered an aptitude for sculpture. She whittled animals and figures in soap or pieces of orange crate wood. She also carved pieces of chalk from a local outcrop where chunks could be cut off and soaked in water to make them workable.

When she was still startlingly young he gave her, and taught her to use, a small Smith and Wesson revolver. Janet referred to this as her 'first gun'.

Janet was ten years old when John Darnell died. She later recalled that after his death there were a few surprises for the family when 'it was discovered that he had been drinking heavily for a long time. He had a medical prescription for a pint of whisky a day during his illness, and this was during Prohibition. As his coffin was lowered into the ground, we the family stood on one side while on the other side stood about a dozen weeping women all elegantly dressed, and I could sense tension. I later learnt that they were the leading madams in Dallas. I was a lot older when I realised the odor I always associated with him was whisky.'

In 1929, at the height of the economic boom and riding high on the current tide of confidence like everyone else, Walter bought company shares in Mobil

Oil and at the same time took out a mortgage on a house for the family to become home-owners for the first time. Janet was eleven years old when later that same year the Wall Street Crash rendered the shares worthless, and being unable to keep up with the payments, the family lost their house. But even more worrying for them, at the same time as these financial disasters were unfolding, Walter's near sight began to deteriorate and he was forced to give up his job as an accountant, and to become self-employed. He sold the family car and bought a lorry to transport fruit and vegetables, overnight, back and forth across four states between Texas and Georgia, travelling and sleeping in the lorry.

Janet's first gun

Five years later he was back in Grand Saline running a filling station, having exchanged the fruit lorry for a six-wheeled petrol truck equipped with oil tanks along its sides. He taught Janet to drive in this enormous vehicle when she was sixteen. 'We had no car so I learned in the truck. It was great fun. Every wagon and team, or Model T had to pull off the road or stop when we came along the narrow rutted country roads and single-track bridges. Dad was head and shoulders better than the average truck driver. My dearest memories are of him driving along whistling the St Louis Blues.'

Janet's great grandfather Tom Darnell was 'one of the local characters of East Texas. For two years from the age of ten he had been a bugle boy for the South in the Civil War. Later he lost his left arm in a cotton gin accident, but undeterred, he still farmed, hunted, fished and rode horseback, saddling up himself. It was said that he could roll a Bull Durham cigarette going full trot. He had a full beard so no collar and tie was needed.' Janet remembered that he would occasionally just saddle up without a word and ride off, wearing a green brocade weskit, sometimes disappearing for a couple of weeks at a time. 'Farmers in our area never had saddle horses, that was a luxury, almost immoral, but he did. Life was earnest, not many took time off to go fishing or hunting, but he did. And he was one of the warmest, most generous, God-fearing of the lot, though he liked a drink.'

Perpetual Motion

Perhaps due to the extreme discipline imposed on her as a child growing up in the Darby household, Janet's mother Ollie was a very solitary person who went to great lengths to avoid company. She also discouraged Janet from meeting anyone outside the family. Janet didn't fully understand the reason for her mother's reclusive character, but Ollie had been a country school teacher, and as Janet said, 'she always felt like the country girl come to town and was never at ease in Dallas or Houston and she never made any friends.' Whatever the underlying cause of her social phobia, to avoid having to engage in conversation with her neighbours, Ollie kept the family on the move, going back and forth between Dallas and Grand Saline. Wherever they were they were constantly moving house to a slightly different location, so Janet often felt very isolated, growing up with no brothers or sisters, and having to attend seven or eight different schools. Her father calculated that for ten years they moved house on average every three months, always going to a house with an almost identical layout so that the rugs, curtains and furniture would fit. The rent was always the same, and the endless uprooting was never to better their situation, but simply to get to a new area where they could start again with neighbours who didn't know them. Janet was a bright child doing very well academically in spite of her disrupted education. While she could deal with her school work quite comfortably, under the circumstances it was hard for her to make friends and when she did, it was hard for her to keep them.

Although her mother was determined to clamp down on her social life, Janet managed to have covert adventures as a teenager, including flying in a small plane with a boyfriend, while her mother thought she was at the library. Towards the end of her life Janet mentioned to me that she had married this 'boy' when she was twenty, but she told me no more about him except that they were divorced the following year. His name was Sidney Roland; he was the first of her three husbands.

Leaving Home

In 1933 Janet left school aged fifteen, in the midst of the Depression. She left her parents in Grand Saline where they were living once more, and returned to Dallas to lodge with a great aunt and uncle in order to study sculpture, first at Aunspaugh Art School, and then at Dallas Art Institute. Janet described her great aunt as 'extremely warm and kind'. She was Janet's Grandmother Darnell's younger sister, who had married a Darby, one of Ollie's older brothers. This great aunt spent much of the time alone as her husband was away

travelling all over the South selling cotton seed. Their house was in the red light district, where rents were cheap.

Janet's art school studies included life drawing. Willing models could always be found conveniently close by, perfectly happy to be roused from their daytime sleep, to get paid for doing absolutely nothing at all. Janet remembered that after a late night's shift they were often happiest to pose lying down with their eyes shut. When Janet's mother realised her daughter was spending her days drawing these shameless women she put her foot down, forbidding her to continue with her studies.

In a stroke of good luck, at the same time as Janet's art classes were so abruptly cut short, her grandmother heard that the Historical Museum in Austin was looking for sculptors to make figurines for a series of historical dioramas for the Texas Centennial Exposition of 1936, marking one hundred years since Texan independence from Mexico. Janet was touched and amused by her loving grandmother's notion that to judge by Janet's soap carvings, she was a highly talented sculptor, and in a move that Janet described as 'a miracle' her grandmother secured Janet a job with the museum on the strength of her collection of Janet's soap carvings which she took along to show the interviewer herself.

Thus Janet was taken on by Mr Willkie, the cockney boss of the project, and his wife. The project was based in a Houston workshop, where for the first time Janet learned to use band saws, drill presses, lathes and other machinery. She liked the Willkies, and found them very entertaining. Mr Willkie was a small man who had been gassed in the First World War and in Janet's words he was 'expected to die of starvation, but had somehow cured himself by living entirely on beer for many years … His wife was large and loud and kindly. I could imagine her bouncing him on her knee.'

While she was in Houston Janet also taught metal work, wood carving and model building at the Houston Handcraft Shop where she was able to exhibit and sell her wood carvings. Thus her career as a professional artist began.

She enjoyed life in the Willkies' workshop, where her co-workers came from widely differing backgrounds. As well as learning new technical skills she was also very happy to be discovering new social possibilities. Later Janet wrote of this time, 'A cosmopolitan interest in other people and other races became a major force for the rest of my life.'

With her new friends she became involved in arranging accommodation for groups of Spanish Republican refugees as they travelled through Texas. Having escaped the escalating conflict in Spain, they were on their way to find sanctuary in Mexico. Janet had once painted signboards for her father's

filling station and the neighbouring café, and now she turned her graphic design talents to producing posters advertising public talks on the Spanish Civil War. She learned to speak some Spanish through her new connections, and on hearing their first-hand accounts of the brutality of Franco's Nationalists, her left wing political convictions were galvanised and she joined the Communist Party.

With money from the dioramas, supplemented by earnings from carving heads, hands and feet for string puppets, Janet found she had enough put by to pay for a Greyhound bus ticket from Texas, which she described despairingly as having 'no art', to New York City, where she was determined to make her living as an artist.

Curious to find out what Janet had meant by 'no art', about twelve years after she died, while researching for her exhibition at the Leach Pottery, I looked up 'Texas art' online. Amazingly, at that time I could only find two entries and both were for Bradley's Funeral Home, where perhaps the art was embalming of some kind. Maybe this was a reflection of early internet take-up as much as anything else, and there are plenty of entries now, but Bradley's Funeral Home left me with an indelible impression of what Janet might have meant.

CHAPTER 2 **New York City**

So it was that in 1937, aged nineteen and with fifty dollars in her pocket, Janet arrived in New York City, with an ambition to visit the National Museum of the American Indian at the southern tip of Manhattan. It held a large collection of pre-Columbian bush-fired pots which she had come across in books and admired for their organic forms. She hoped to absorb and adapt elements of their design for use in her own sculpture, but at this point she had absolutely no desire to make pots.

In Manhattan Janet found herself living in the midst of the great gathering of renowned European artists who, escaping the growing menace of Nazism in Europe, had recently crossed the Atlantic to reach New York. Here at last she found the cultural riches she had yearned for, and taking full advantage of her new situation she set about visiting the galleries. In the recently-opened Museum of Modern Art she was overwhelmed by the sight of Giacometti's sculptures and the paintings of Picasso and Van Gogh. Janet also enjoyed the live music scene of New York's many jazz clubs. She rented a room in a cheap tenement in SoHo and later said, 'Leadbelly lived up the street from us, I liked that kind of folk music.'[1]

Taken aback to discover there were strict gun laws in New York, and having no idea what else to do with it, she dropped the gun she had brought with her from Texas into the Hudson River.

Janet spent twenty of her fifty dollars securing a place studying sculpture in the American Artists' School in New York, where one of her tutors was Robert Cronbach. She pointed out, 'this was the Depression, it didn't matter what you studied there were no jobs, so you might as well study art.'[2] In fact she quickly found employment with Cronbach, who recognised her potential and hired her to enlarge and cast his sculpture on an architectural scale for public projects. This led to her working for him for a total of nearly ten years, before and then again after the Second World War.

At the age of twenty-one, profoundly disillusioned by the 1939 non-aggression pact between Stalin and Hitler, Janet turned her back on the Communist Party, and cancelled her membership.

Between 1939 and 1942 Janet worked in the sculpture division of the Federal Arts Project which was established as part of F.D. Roosevelt's New Deal, whereby sculptures were commissioned for schools and public buildings, to provide paid work for the artists, and to enhance the cultural environment

for the population. Through this project Janet found work with several well-established artists, as well as designing and making her own commissioned pieces. 'There I was, in the company of stonecutters, old Italian casters and young artists.'[3]

After four years in New York, at the age of twenty-three, Janet married again. Her second husband was a skilled shipyard worker called Joe Turino. This marriage was also very brief and before long he was drafted into the Navy and they went their separate ways.

The Federal Arts Project ran until the United States was drawn into the Second World War following the Japanese bombing of Pearl Harbor. Soon afterwards, in 1942, Janet went to work in the Bethlehem Steel Shipyard on Staten Island, confident in her mastery of machine tools, which she had acquired through her training at the Houston workshop.

Initially she was hired to drive and unload lorries, but the pay and conditions were very poor and she realised it would benefit her to qualify as a Navy Certified Welder, leading to higher earnings and the furtherance of her own sculptural training, given that war work at the shipyard was, in her words, 'the only way a woman could ever get this kind of experience with metal.'[4]

Having gained her qualifications Janet spent three and a half years welding hulls, forward assemblies and bows in the last stage of production of ten destroyers. She was one of a small group of women employed at the shipyard, hired partly to demonstrate that they were not up to the job, so that the male workforce could be declared indispensable, and therefore exempt from the draft. As it turned out the women proved themselves to be good workers and were quickly accepted by both the management and the union. To shorten her daily journeys to and from the shipyard Janet moved from the centre of the city to a houseboat on the Hudson and bought a small 32cc motorbike to help her get about. She named her motorbike Dude.

In war-time New York Janet's disquiet concerning the social and political realities of the time continued to grow, as increasing numbers of political refugees were arriving from Europe. She was also discovering shocking details of racial segregation and discrimination which were all part of the humiliating treatment endured on a daily basis by the black Americans working alongside her at the shipyard. She learned that until they were needed for the war effort, their own needs had been entirely neglected, but now for the first time they had their basic health and housing requirements covered.

After the war Janet returned to work for Robert Cronbach and also resumed her own sculptural practice, working in metal. She exhibited her sculptures in group shows in a 57th Street gallery, but found it increasingly disheartening

to make metal sculpture which was heavy to move and which ultimately didn't find a buyer. She spoke of bringing it home again once the exhibitions had closed, hauling it back across town to 3rd Avenue and up five flights of stairs to her room. She discovered nobody at that time wanted sculpture and that many sculptors found their working space getting crowded out by their unsold work. She felt she was 'floundering around' and wrote ruefully of her own experience of 'sculpture that starts piling up on you if it doesn't sell.'[5]

Meanwhile, quite by chance, she heard about the ceramic work produced under the guidance of Aimee Voorhees and her sister at Inwood Pottery Studios in its new location on 168th Street in Upper Manhattan. She was interested to find that their pottery incorporated decorative designs inspired by fragments of Native American pottery unearthed in Manhattan during the initial excavation of the subway system. The Voorhees sisters were themselves no longer potting, owing to arthritis and their advanced age.

Although pottery was becoming very popular, Janet had always thought of it as a lesser art form than sculpture, but in 1947, feeling thoroughly disillusioned with trying to make a living as a sculptor, she paid a visit to the Inwood Studios, where she was impressed by the lively working atmosphere the Voorhees sisters had created. Their studios, bustling with activities provided for the public, included lessons in pottery, glazing, firing, casting, and sculpting in clay. They also hired out fully-equipped workshop space for the public to use for their own projects. Janet asked to join them. For over two years she worked at the Inwood Studios making pots, and eventually assisting Aimee Voorhees with her classes, teaching ceramics to adults at Manhattan colleges, including Hunter College, renowned for its academic rigour, promotion of the liberal arts and multicultural student intake. At this point Janet sought out a sizeable room on the top floor of an old tenement building nearby, aware that the oldest tenements always had the biggest rooms.

Later Janet wrote of this fruitful time spent with Aimee Voorhees, where her attention was first drawn to the work of Bernard Leach: 'Under her tutelage I discovered a philosophy of art and life for which I was searching, and under her guidance and introduction to Mr Leach's *A Potter's Book*, new doors were opened ... Finding a piece of my pottery in daily use was rewarding ... I began to feel related to nature and its organic flow as I produced the work, and I felt related to society as I saw it in use, and giving daily pleasure.'[6] Janet was known to say how pleased she felt the first time she saw someone put potatoes in one of her bowls, although by the end of her life she was adamant that her pots were not intended for domestic use. As her working life progressed her pots became one-off expressive pieces, and once she had

found her own style, she refused to compromise the aesthetic aspect of her work with considerations of 'food-safety'. As she was interested in the surface of the clay, she often left it wholly or partially unglazed.

Upstate New York

After her introduction to pottery at Inwood Studios, Janet knew she had to organise a work space for herself. So, resourceful as ever, she set about establishing a pottery and sculpture workshop in the occupational therapy department at Rockland State Hospital, the biggest mental hospital in New York State. This was the first pottery workshop in any of New York State's mental hospitals. Each weekday for three years she taught two classes to the patients, and twice a year she held selling exhibitions of their work. Each session was attended by about fifty patients and she was accompanied by two assistants.

Once the pottery was up and running for the patients, Janet introduced evening classes for the doctors, nurses, social workers, office workers, orderlies and attendants. She also advised and instructed therapists who had been sent to her from other hospitals, to learn the skills necessary to set up potteries for their own patients. This was a Civil Service position and Janet was given a permanent contract, but because she had no desire to get stuck doing this for ever, she resigned after two and a half years, and moved away to Saddle River Handcrafters in New Jersey, where she set up a pottery and shop, and introduced ceramics as part of the Handcrafters' programme of adult education. The Handcrafters pottery also served as Janet's personal studio and she was able to sell her work in the retail department. All the while she was also teaching pottery to adults and children in various locations in New York State and New Jersey, as well as giving public talks and demonstrations.

Certain now that she wanted to earn her living through pottery, in 1950 Janet attended a six-week summer school at the highly regarded Alfred University, New York State College of Ceramics, taught by professional potters under the leadership of Marion Fosdick. At this specialist ceramics college, with its progressive principles and well-equipped laboratories and studios she learned a great deal more about the technical aspects of ceramics and glaze chemistry.

That same year she heard Bernard Leach speaking for the first time when she attended a lecture he was giving in New York.

In 1952 Janet moved to a Steiner community at Threefold Farm in Spring Valley, Upstate New York, where with the help of friends she built herself a cabin. She established a pottery workshop and kilns on the adjoining land, available for anyone at the farm to use, where she taught a group of children

each week. For two months each summer she held daily pottery classes for about twenty-five people.

Aspects of the Steiner philosophy stayed with Janet for the rest of her life, particularly its 'holistic' stance and its emphasis on enquiry and creativity. It provided her with a fitting ideological replacement for Communism and the Methodism of her upbringing, although she was by nature always wary of too much 'group think' in any political or cultural movement. It was while she was at Spring Valley that Janet bought a pot for the first time, an unglazed, burnished black bowl made by Pueblo potter Maria Martinez. It cost her five dollars. She kept it close by for the rest of her life, even carrying it with her when she went to Japan later on. She said she never grew tired of it and eventually it sat on a shelf next to a plain black glazed Hamada plate in the Pottery Cottage kitchen at St Ives.

Meeting Bernard Leach and Shōji Hamada

In 1952, during her first year at Threefold Farm, Janet visited Black Mountain College in North Carolina to attend a two-week pottery seminar hosted by Bauhaus-trained potter Marguerite Wildenhain, and conducted by Bernard Leach, Shōji Hamada and the founder of the Japanese Mingei (Folk Craft) movement, philosopher-critic Soetsu Yanagi, who were touring their series of seminars across the United States, including venues at Black Mountain and New York.

Black Mountain College was established in 1933 with artistic experimentation and freedom of expression as its guiding principles. The weaver Anni Albers and her husband, painter Josef Albers, had both taught at the Bauhaus in Germany, and together they moved to Black Mountain College when the Nazis forced the closure of the Bauhaus. The Bauhaus founder, architect Walter Gropius, also spent time at Black Mountain College. Painters Willem and Elaine de Kooning taught there and took part in college events. In 1948 Elaine de Kooning had worked in the college grounds with Buckminster Fuller on a trial run for his first full-scale geodesic dome.

As an independent thinker who was always eager to expand her experience, Janet was naturally drawn to the extremely avant-garde atmosphere of Black Mountain and thus she opted to travel nearly seven hundred miles to North Carolina rather than attend the New York seminar on her doorstep. She said, 'I fancied the ambience.'[1] Later that same year John Cage, Robert Rauschenberg, Charles Olsen and Merce Cunningham staged what is considered to have been the first 'happening' at Black Mountain College, where poetry, dance and music were all performed simultaneously, in the same space.

Shōji Hamada, Bernard Leach and Soetsu Yanagi
at Black Mountain College, 1952

During the Black Mountain seminar, while watching Hamada on the wheel, gently coaxing the clay into life, having barely centred it, Janet realised how rigid her own approach to clay was, and how self-conscious and lacking in vitality. She had been treating the wheel like a lathe. She later reflected, 'I had a death grip on the clay. My pots had no life, I was a very good mechanic in those days.'[7] Hamada's easy approach to clay seemed to Janet as if he were playing pat-a-cake. This made an impression on her that would change the course of her life. His playful methods were the very opposite of her 'death grip'. Hamada seemed to her to stop making a pot just before it was ready: 'as the pot burst into life, and as you wondered what he was going to do next, he stopped.'[8] Such spontaneity prevented the pot becoming over-worked or slick. Later, referring to his very quick, apparently slapdash turning methods, she said she went to Japan 'chasing that shocking foot ring', adding, 'if you didn't know about Japanese aesthetics, Hamada's turned bases would shock you.'[9]

As well as his shocking foot rings, she admired Hamada's slip brushes, and having assumed they were very special, was surprised to see him making one as he strolled around the gardens, simply pulling the seeds from dried grasses before tying the stems together with cotton and poking them into a hollow reed he found. He also made a good brush for iron oxide decoration from a pinch of fur he cut from the scruff of a dog's neck.

During the fortnight of the seminar Janet and Bernard Leach struck up a friendship, and Bernard later wrote, 'It was here at Black Mountain that I danced one evening with Janet Darnell and found her mind alive and intelligent. She told me that when I talked about "tradition" nobody understood what on earth I meant.'[10] Janet explained to Bernard that in America, 'crafts were what you taught Boy Scouts.'[11]

Janet Darnell

November 16, 1952
Threefold Farm
Spring Valley, N.Y.

Dear Mr. Leach:

When I last saw you you were much too harrassed for me to tell you that it was my intention to write you before you left this country. I certainly hope that all three of you have had a chance to refresh and enjoy yourselves since I last saw you. Please give a very warm hello to Dr. Yanagi and Hamada for me.

I wish it were possible to adequately express my appreciation for what you all are doing in this country. I feel that you are making a tremendous personal sacrifice, but it is to be expected that you would see the great need and do something about it.

What the seminar meant to me personally would be difficult to express. I came came with very high expectations and still I got more from it than I ever hoped for. The opinions you expressed so modestly about the Eastern contribution of organic form should be repeated constantly. I feel that it is one of the keys which will open many eyes when comprehended. I believe that is why sculpture is suffering so badly. There is no real concept of form. We have a sensitivity to tone and color but no counterpart in responding to form. It is that interest in form which took me out of sculpture and into pottery. In sculpture there is anatomical form and abstract form but there is no life in the form itself. After seeing the non-mechanical approach that both you and Hamada are able to take on the wheel, I am quite excited. I had always felt the wheel was very cold, and was more interested in the more primative methods of the Indians as a source of form.

Well, this is what I've been trying to get around to saying: As someone who knows the conditions of the East quite well, would you think it would be possible for a woman to study under Hamada in Mashiko? Providing, of course he was willing. It was in my mind all the time I was at Black Mountain, but I felt that I should come home and think about it from a distance. I have thought of nothing else since. I have a strong mechanical aptitude which could only be conquered by such an experience. I know of nothing that I have ever wanted to do so much, but would I be worth his time. I don't know, I could only promise that my heart and soul would be in it.

Janet's first letter to Bernard

After the two weeks at Black Mountain College, Janet was clear about the direction she wanted to take in her pursuit of life as a potter. She had gone to the seminar to learn from Bernard Leach, and had enjoyed his company on a personal level, but had found the greatest working inspiration came from Shōji Hamada. He had shown her something new about 'the thinking behind the potter's wheel'.

Janet knew the itinerary for their American tour and after much deliberation she wrote to Bernard asking if he thought there was any possibility that Hamada might allow her to spend some time working in his pottery at Mashiko. She addressed the letter to one of the future venues Bernard, Hamada and Yanagi would be visiting during their travels, so that it would be there when they arrived.

Of course neither you nor he know anything about me— I come from a very average middle class family and at 18 left Texas for New York to study sculpture- without their sympathy. I am now 35 and still consider myself a student, but until Black Mountain I didn't quite know where to turn. I spent a summer at Alfred and learned many formulas, but in all the six weeks they never once mentioned what makes a good pot. Since I did not feel that was what I wanted, I've been working on my own, not because I think I'm ready, but there seemed no other way. For about 10 years I worked under a sculptor as his assistant, doing architectural sculpture, so I believe I know how to work for or with someone else, doing what is needed.

I have a faint suspicion that Mr. Hamada has never thought of having a woman study under him. If that is so, I would like to assure him that I have been taking care of myself for about 17 years. I was married for a short while. I have worked as a truck driver for the Army, as a welder in a ship yard, and have worked in plaster shops with Italian craftsmen who point blank told you to go home and have babies, but finally broke down and accepted working with a girl. Therefore I would not be half as afraid of the situation as he probably would. There is an old saying about a Texas woman-- no matter what happens, she's always seen worse.

At the moment I am living in the country in a small house that I built and my needs are quite simple. If I thought it were possible to study under him, I would get busy and work hard enough to get the money together. If he would take me, how much would his charges be and how much would it cost to live in the simpliest possible manner in Mashiko? I assume I would need to stay at least a couple of years- what would he say? Actually the reason I am mentioning this to you is that I am leaving it up to your discretion whether to even mention it to him or not.

Whatever it may be, I want to express my most sincere and deepest gratitude for the generosity and effort you all are putting out on behalf of such as myself.

Very sincerely yours,

Janet Darnell

Janet Darnell

CHAPTER 3 **Across America to Japan**

For over a year Janet heard nothing back, and so she assumed her request had come to nothing. Then just before Christmas 1953 she received a letter from Bernard telling her of Hamada's invitation to come to Mashiko the following May. Hamada had asked Bernard to write to Janet for him because he was unable to write in English, although he could understand and speak it reasonably well. As she absorbed this news, Janet realised she had less than five months to earn enough money to cover her train ticket across America, her Pacific sea voyage to Japan and her living expenses in Mashiko.

She had been living on her pottery sales, supplemented by part-time employment back in Manhattan, designing industrial light fittings for the Luxor Lighting Corporation which was based in the Empire State Building. Janet found the work with Luxor tedious, but with the sudden prospect of a journey to Japan and the urgent necessity to raise as much money as she could, she increased her working hours for Luxor to almost full time, spurred on by her calculation that a week's wages with Luxor would pay for an entire month in Japan.

Janet had typed her first letter to Bernard because at the seminar he had mentioned that the Japanese judged people by their handwriting, and she was very self-conscious about hers. Bernard was writing a diary of his travels around Japanese country potteries, and when he replied to her he added, 'I see you type', and asked her to bring a typewriter with her to Japan, so she could help him with his work. She was extremely glad of this opportunity for some paid employment while she was away.

As the time approached for her to embark on her journey to Japan Janet was treated to farewell parties with many of the friends she met during her time in New York State. She said, 'My friends from the past four or five years at the farm have become increasingly touching, with the lovely goodbyes and all the help and good wishes I went off with.' Then, just as she was packed and ready to leave Threefold Farm her self-confidence was given a further boost when a visitor turned up to ask her if she would set up a pottery and teach in a high plateau area of Angola where there was good local clay and plenty of wood for firings. She had to decline the invitation.

Janet set off from New York's Grand Central Station bound for Chicago, where she boarded *The Empire Builder* for the westward railway journey of more than 2,000 miles, through eight states, across the country to Seattle. In

Seattle she was due to board the ship which would take her to Yokohama. As she had previously only known Texas, New York, Black Mountain and New Jersey she was enthralled by this journey across parts of America she had never seen. After leaving Chicago, memorably for Janet the train passed through the forests of Minnesota, and across prairies of endless wheat fields, where for an entire day she did not see a soul in the landscape. Sometimes as the journey progressed she managed to slip through unnoticed to the first-class observation deck where, with more than half the distance covered, she watched as the train crossed the Rocky Mountains, passed lakes and rivers where she saw beaver dams and lodges, before skirting the southernmost edge of the Cascade Mountains.

Later Janet spoke of being, 'so glad to get a taste of this land before leaving it. It was a beautiful farewell, though I didn't know then I wasn't coming back.'[12] She had always intended to return to Threefold Farm after her visit to Mashiko, but as it turned out, once she had left for Japan she never lived in America again, only ever returning for brief visits.

After this epic journey across the country to Seattle, American Mail Lines repeatedly postponed the Pacific sea voyage, providing little notice of the changes. Bernard was already in Japan, and wanted to greet her when she arrived, which meant keeping him updated with the new sailing schedule. Eventually, on 19 May Janet left Seattle on the cargo boat SS *Canadian Mail*. She wrote, 'as we sailed out, under beautiful clear sky, Mt Rainier emerged, like a vision. Snow covered cap visible in the sky.'[13]

Janet's airmail letter to Bernard and Soetsu Yanagi

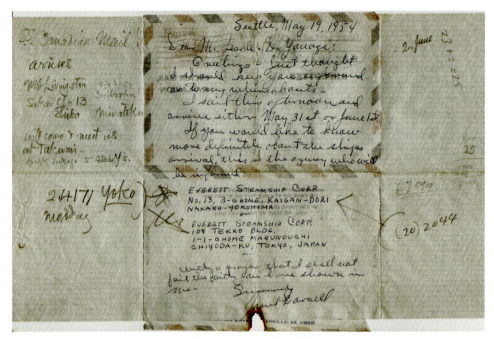

Janet's airmail letter to Bernard and Soetsu Yanagi

The boat continued down the Puget Sound, stopping at a lumber camp where the crew loaded timber all night under a full moon. Two days later there was no longer any sight of land. Janet wrote, 'I had planned on recording more, then instead got rocked to sleep.'[14]

Like many things in Janet's life this letter has a cigarette burn in it, though whether the cigarette was Janet's or Bernard's it's impossible to say. It could have belonged to either of them as they were both keen smokers. Later they planned to give up, but Bernard didn't get round to it until he was eighty-eight, and Janet never did. At this stage in her life she had not yet developed a liking for whisky.

On the first day of June 1954, after twelve days at sea Janet finally arrived in Yokohama. To make sure she was comfortable during her first week in Tokyo Bernard had arranged familiar accommodation for her in a house owned by an American woman who provided Janet with a table and chair in her room and a Western-style bed, so she had no immediate domestic culture shock to deal with. Janet wrote, 'Living Western for a few days while seeing all this is a wonderful way of easing into Japanese life.'[15]

During her first week in Japan Bernard showed her the sights of Tokyo and introduced her to many of his friends. They visited Soetsu Yanagi and the Mingeikan, the Japanese Folkcraft Museum, where among the international exhibits she admired a large collection of early English slipware, a type of pottery she had never seen before. They visited most of the major museums in Tokyo and a Zen monastery on the outskirts.

One of Janet's initial impressions of Japan was of an all-pervading love of natural beauty, with natural elements augmenting the most apparently incongruous settings: '… even in subway and train stations. Imagine seeing flower arrangements or an aquarium in a New York subway station, or a bus driver with a vase of gladioli hanging beside him! Everywhere one turns one sees these little things. Wherever people are living they have a small garden, flowers or a tree. The Japanese refuse to lose their contact with nature.'[16]

However, she soon had to acknowledge that there was another side to post-war Tokyo. 'As Mr Leach and I walked along Ginza in the rain, his was the only traditional Japanese umbrella I saw all afternoon. There is so much plastic everywhere.'[17] Although Janet said she very much enjoyed 'every hurried minute' of her stay in Tokyo, after spending a week there she was happy to be leaving for Hamada's pottery. 'I am glad to be going on to Mashiko tomorrow. I want to see Japan, to experience the richness of its life, find the roots of this culture in its refined, simple living. Here it is attempting to hide its lovely face behind chrome and neon.'[18]

Mashiko

On 9 June 1954 Janet arrived at Hamada's pottery in Mashiko to find herself surrounded by press photographers and reporters intrigued to discover why someone with all the choices open to an American would want to come to Japan to work in a pottery. The fact that Janet was a woman only deepened the mystery. A little later she wrote, 'Many Japanese cannot conceive of their having something that an American did not have at home.'[19] This was, after all, less than nine years since the Americans had demonstrated their immense power by dropping atomic bombs on Hiroshima and Nagasaki.

Shōji Hamada and the younger members of his household greeted Janet warmly when she arrived, although Hamada's wife Kazue was away in Tokyo at the time and did not return to Mashiko for nearly a week. When Kazue finally returned home she made Janet feel wonderfully welcome and did all she could to make sure she was comfortable. Kazue spoke no English at all and Janet's desire to learn Japanese was spurred on by her desire to get to know her better. Janet said, 'I have never known such a warm, kind face.'[20]

Kazue Hamada

Janet arrived in Mashiko the day before 'a siege of glazing' for the eight-chambered kiln, and not knowing how to assist in this intense work, all she could do was to try not to get in the way. The fact that she spoke no Japanese didn't help.

The buildings and surroundings at Hamada's pottery struck her as exquisite: '... every now and again I see tucked away within the shrubbery a magnificent piece of Korean granite sculpture.'[21] These were in fact Korean memorial stupas made to contain the ashes of wandering monks. The buildings of the living quarters and her own room in the deep-thatched gatehouse delighted her. These Japanese houses were composed of a light wooden framework with the pieces pegged together, and finished with wattle and daub, paper windows and a thatched roof. They were designed to weigh very little to provide safety in earthquakes and so that they could be dismantled, transported and reassembled again anywhere. Janet discovered that Hamada collected houses and paid a carpenter to put them together on his compound.

Janet was woken from her first night in Mashiko by cockerels crowing all around the village. She heard frogs croaking in the rice paddies across the road, where later in the day women wearing wide-brimmed straw hats and straw raincoats were planting rice.

After a few days Janet wrote, 'My impression of Japan is that the people have fitted themselves to the land. They drive their cars over hills and around curves that Americans would have blasted out straight.'[22] She was filled with

Korean memorial stupa, at Mashiko

Mashiko 1954. Standing left to right, Richard Hieb, Shōji Hamada, Janet, Mihoko Okamura, Soetsu Yanagi, Mr Hikata. Seated front, Mr Garrina, Mr Kato, D.T.Suzuki and Ms Arada

admiration for a culture that walked through the mud 'wearing shoes raised on thick wooden blocks, rather than tearing up the land and paving it.'[23]

'One of the outstanding things I have observed in Hamada's and other potteries, is that an unbelievable amount of creative work is produced under what we would call very "primitive" conditions, without the use of any so-called labour-saving equipment … Glaze is sieved through pine needles.'[24]

A draft of *Mashiko 1954*, Janet's preface for *Hamada: Potter*

Mashiko, the El Dorado of many Western potters, is a small village which has produced kitchenware for Tokyo for about 250 years. It came into existence with the establishment of Tokyo as the new capital, and potters travelled north from one of the best old potteries in Japan, Karatsu, to found it on the remains of a pottery of a prior civilisation.

The mountains in this area are gentle and wooded and the valleys are broad, making good rice fields. There is a ridge of hills on the horizon with a spine of trees silhouetted against the sky. The potter and his wife and family grow their own rice and foodstuffs as well as carry on their work of potting. There is rarely a day when one does not see a swirl of smoke rising from some kiln being fired. It was in this simple remote community that Shōji Hamada chose to establish himself upon his return to Japan in 1923, after having worked with Bernard Leach when the St Ives pottery was being established. Hamada could have had a much higher position had he chosen to make his life in one of the cities, for he was a graduate of one of the best technical schools of Western ceramic science in Japan and had served as a professor before coming to England to work with Leach. But he wisely chose the more wholesome background of a traditional rural pottery and spent the first five years developing his own work while using the workshops of these potteries. Slowly and surely he grew, acquiring inner strength and assuredness before building his own kiln and workshop. Now his home is quite elegant. His houses are examples of the best architecture of the area, built of adobe-like stucco and huge wooden beams with very heavy two-foot-thick thatched roofs. His gardens are informal, and tucked inconspicuously along paths are outstanding examples of Korean sculpture. His love for the beauty of traditional buildings has led him to acquire them, but his life has remained simple and over all hangs the air of work as related to life, beauty coming from the daily way of things.

The day of my arrival at Hamada's was a memorable one. They were in the midst of glazing and stacking his large eight-chamber climbing kiln. Never have I seen so many pots being handled in so deft a manner. Hamada, his two

Hamada glazing

Hamada glazing

sons and about six workers were in a forest of pots. The workshop is about 30 x 100ft long with a larger ground area in front where pots are dried and down a steep slope is his largest kiln. The entire ground space of all buildings and the adjoining area outside and along the sloping paths was thickly covered with boards full of pots. Nowhere was there a clear pathway for walking, men with boards of pots over their shoulders were stepping over and around other workers with boards, a nimble weaving over and under in a long-rehearsed performance.

All glazing was done on the ground, bending over large washtubs, either pouring with a ladle or dipping. Men were squatting to clean the bottoms of pots. Everyone seemed to know what to do and glided from job to job, anticipating each need and process.

Hamada does all the decoration on his own pots and over half of the decoration on stock items, in addition to indicating what is to be done to the others and instructing as to glazes and their treatment. I watched him decorate over 500 pots with wax and glazes in one day, sitting on a low stool with pots around him on the ground.

His best pots were kept until late afternoon, for the more he worked, the more vigour he had. The work was feeding him rather than draining him. His decorating techniques are principally that of glazes over glazes; sometimes over a thin yellow ochre slip, often with a wax pattern brushed on the first glaze; and his best-known technique is of trailing a large glaze pattern with a dipper. His brushwork is excellent but he uses it only in a large sweeping pattern.

About 5,000 pots were in this firing, many quite large, and most of the glazing, decorating and stacking was done in three working days. This number of pots represented less than two months' work (including bisque firing) by the two throwers who have worked for him for almost fifteen years, his two sons and himself. The kiln firing takes two days and the sight of men stoking small split sticks of pine into each chamber successively, with the resultant belching flames and smoke from the portholes, is highly dramatic. The temperature reached is about 1250°C. No cones are used, temperature and heat dispersion are judged by eye.

The firing is oxidation throughout the kiln, with the exception of the first chamber, which always tends to be neutral-to-reduced in the climbing kiln. In this chamber he uses different glazes, such as the runny treacle-like glaze, with the pots set on shelves for stilts. The kiln was allowed to cool for a day before opening. Two full days were needed to unload, sort and instruct the packer as to shipments; two more days to finish grinding bottoms of pots

Hamada pouring glaze

Glazing Hamada's wax resist decorated pots

with hand stones, stack saggars and clean the kiln floor and working area. Hamada has two kilns, one of five medium-sized chambers and a much larger one with eight large chambers. He averages firing either one or other of these every six weeks. While I was there he also began his experimentation with salt glazing, using the last chamber of the small kiln. Almost no salt has been done in Japan.

To my eyes, his work cycle represented a miracle, without even taking into consideration the quality of the ware. He prefers not to spoil the working atmosphere by the use of mechanical equipment. The spirit surrounding the pottery is relaxed and free. Hamada has a hearty ease about him which passes on to the crew, and is reflected in the pots as well. There are few seconds, but there is also little apparent concern over the 'imperfections of nature'. Uniformity is not their conception of quality.

In rural Japan there is no Sunday, work is continuous until firings. During the kiln watching, cooling and opening there is a relaxed period of semi-holiday before preparations start for the next session of work.

The workshop is a long stone and plaster building with a thick, high-pitched thatched roof which overhangs the building by about six feet, providing ample space for vats of glazes and materials and drying racks under its eaves. Along the entire length of the front of the building are sliding paper-covered windows which give the most pleasing light I have ever worked in. There are racks along the back wall as well as overhead, everywhere. In the centre of the earth floor is a two-feet square bricked depression, a few inches deep. This is the fire-place which serves as a source of heat to dry pots, sandals and oneself; and, as everywhere, there is a black kettle suspended over it. Running the length of the building under the windows is a bench-like structure about two feet high and six feet wide. This built-in platform is the only working area other than the earth floor. There are no other tables, stools or benches.

Interspersed along this structure there are thirty-inch-square spaces accommodating eight potters' wheels. Some are Korean-type kick wheels and some are hand wheels turned with a stick.

Clay is delivered by horse and wagon from an adjoining 'clay maker's village', where it has been washed, sieved and dried, ready to be wedged. The men mix large mounds of it with their bare feet on the earth floor of the shop. After mixing it is left on the floor in heaps. Slices of between thirty and fifty pounds are cut off and wedged on the edge of the platform next to the wheel.

Their manner of rolling and kneading, though arduous, is not as strenu-ous as our method as they never lift up the bulk of clay, and when their final hand-kneading is completed the resultant rolls of clay are automatically in a

Hamada decorating

convenient working position for the wheel. If the clay is too soft, large pats of it are thrown against the stone wall outside, underneath the windows, and a board is placed on the ground to catch it when it dries and falls off.

In every stage of work there is a natural flow of convenience and availability without intellectual planning or organisation. They intuitively use the elements and materials supplied by nature around them; a wad of dried straw rolled and tied makes the best brush I have ever seen for washing the bottom of pots; a similar brush is made for washing the kiln shelves and saggars, straw alone is used for packing, and the packer makes his straw rope as he proceeds. Pots are dried in the sun and wind. Glazing is done outside, so that no thought has to be given to drying the pots before firing in the slowly heated kiln. Miscellaneous bowls, boards and utensils are set outside to be washed when it rains.

The Korean wheel is simple, consisting of two circular wooden discs, about fifteen inches in diameter and four inches thick, joined by four posts, making a unit about twenty inches tall overall, which spins on a pointed stick set into the earth. The wheels are set centrally in the cut-outs in the workshop platform with the wheel head level with the platform. The potter sits on the edge of the structure with his feet in the hole, and kicks the lower disc. Some of the potters rotate the wheel clockwise by pulling forward with their right foot and toes. The hand wheel, consisting of one disc about twenty-eight inches in diameter, is always turned clockwise for more power. This tendency has been carried over to the kick wheel, although it is not considered theoretically correct. There is much less power in any of these lightweight wheels than in any of the Western types but as with everything else in Japan the work is not accomplished by power or push, and centring is achieved by deft persuasion rather than power.

As I watched the throwing whether by Hamada or one of his men or by the numerous throwers in any of the traditional potteries along the roads of Mashiko, the realisation was always the same: the skill and fluidity of movement and the resulting work are the outcome of an approach which is foreign to us. This is best described by words such as ease, naturalness, attunement, non-aggressiveness and so on. There is a harmony of living and working. Work is not merely work, it is life. Whatever a man is doing he is doing with his whole being, without self-consciousness or apparent physical discomfort or fatigue When he is throwing he is completely in his work, when he stops for a smoke he stops completely. He takes long breaks for tea and chats and plays with the dog, watches a butterfly or picks a flower to put beside his wheel. There is never a halfway attitude. This results in clean, sure movements,

Smoke break, Mashiko

Hamada with recently-fired pots

Hamada's fired pots alongside kiln

always just enough, never indecision or fiddling. Pots grow, are cut and set off, grow, cut, and set off, with the rhythm of breathing.

When Hamada is throwing it is clear that he is conscious solely of the nature of the material he is using, clay, and of the form he envisages. There are no regulations governing accuracy. He is striving for the spirit of the form in clay, the pot comes up and at the first spontaneous burst of life he stops working it. It may not be quite smooth, even, or centred, but these factors are secondary and he does not sacrifice vitality for the sake of mechanical perfection.

When discussing glazes with Hamada, who knows more about glaze chemistry than most Western potters, he told me that on his recent tour through England and America many potters thought him to be a simple peasant because he used only wood ash, ground stones, feldspar and rice husk ash for his glazes, whereas Western potters use long lists of chemicals calculated by molecular weight etc. He chuckled and said 'they think they are being very complicated and I very simple, but in truth it is I who am the more complicated, I am using nature's mixtures, which are infinitely more complex.'

An example of his lack of precise methodology occurred not long after my arrival. In the main room of his house is a square fireplace similar to the one in his workshop where all the crew, the gardener, the old carpenter and the family gather each morning and afternoon for tea. A kettle boils over the fire and all the trash is burned there. One evening as Mrs Hamada was combing the ashes we were amused by the variety of hardware that appeared, including the metal capping from a Japanese umbrella, small tin ornaments from traditional wooden sandals and such. This completely random ash was washed and sieved for glaze. There was no concept of a 'type' of ash.

When the kiln had cooled sufficiently after that first firing, Janet took the opportunity to make herself useful, and set to work, happy to be grinding the bases of the fired pots as they were unloaded from the kiln. She said, 'Standing knee-deep in pottery from Hamada's kiln is any young potter's dream come true. I was able to work alongside the rest, carrying the pots from the kiln and setting them out. It is heavy, hot work but exciting and it was a pleasure to feel at one with the rest of the crew rather than an oddity and a spectator.'[25]

During the kiln unpacking Hamada was picking out the pieces he wanted for exhibition while Janet looked on: 'The packer came and I watched in fascination as he twisted ropes from grass, then wrapped and bound bundles of pots together in the most skilful manner. He worked calmly and smoothly with no apparent rush and no wasted movements whilst accomplishing a tremendous amount.'[26]

As Janet describes, the Mashiko clay was dug and initially prepared in Kitagoya, the clay makers' village, a couple of miles from Mashiko. The Kitagoya hills yielded various types of clay, of different colours.

Kitagoya: digging clay

Loading clay for transport

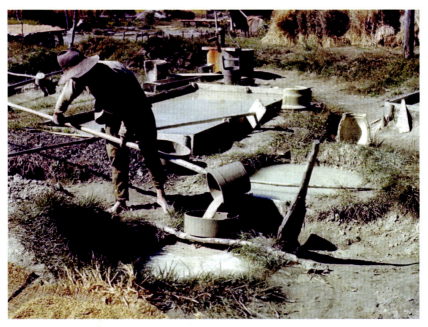

Sieving clay slurry into settling tanks

Spreading clay on bamboo mats to dry

That summer Hamada's pottery was fulfilling an order for thousands of press-moulded porcelain buttons, which provided Janet with some work to do, though not what she had imagined.

Bernard wrote in *Beyond East and West* that while Hamada was considering Janet's application to work at Mashiko he had told Bernard, '… she's a woman and there are no women potters in Japan, but I feel this student is exceptional.'[27] Janet was unaware of this conversation and had no idea that in Japanese potteries although women worked hard, their work was confined to preparing the clay, and general tasks such as fetching and carrying, as well as decorating pots. Women did not make the pots themselves nor use machinery. For some reason Bernard did not warn Janet about this before her journey to Japan, but she had worked too hard, invested too much hope, and travelled too far to get to Hamada's workshop to simply step back now, and so she remained quietly determined to throw pots, managing eventually to experiment on a Korean kick wheel in the pottery. At first she found it very hard to get used to, a tiny wheel with no momentum, her knees tucked up almost under her chin, but she persevered and started to produce some finished pots. In the end she was able to find a spare wheel to use for about half of each working day. These Korean wheels were what she later came to refer to, for obvious reasons, as Japanese wheels.

Janet's considerable courage and resolve must have been vital resources for her survival in the Mashiko workshop, since she realised almost immediately that as a woman in what she soon discovered was a thoroughly male-dominated situation, it was going to be almost impossible to find genuine acceptance. She wrote telling Bernard that in the workshop she was seen as a 'freak'. Still she persevered, and somehow managed to find a balance between the natural courtesy befitting a genuinely grateful guest, and a refusal to accept the conventional limitations that would prevent her from performing the 'man's work' of throwing on a wheel.

So it was that Janet worked on a wheel and, as if it didn't apply to her, she wrote to tell Bernard, 'women do not travel, women do not work on the wheel, I can only work in rural Japan with a ring of black eyes on me at all times. Women have a different social status in Japan.'[28] At the large dinner provided when the first firing was completed she joined the crew only to find that the other women had all disappeared and she was the only one left at the meal. She said she thought it was quite likely the first time many of the men had ever dined with a woman at their table and she said, 'Never have I been so conscious of being a woman.'[29]

Bernard wrote of Janet's life at Mashiko, 'She had become accustomed to not pushing herself forward, because it was a man's country. She saw clearly

Attaching handles

Glazing pots

Preparing pots for firing

Splitting wood for stoking kiln

Packing pots for delivery

that to get the best out of her experiences she would ... have to play a retiring role.'[30] I think on the contrary that given the circumstances she was remarkably bold, and although it was never her ambition to become 'the first Western woman potter in Japan', her courage and perseverance in following her long-held dream led her to becoming just that. Perhaps, if Hamada is to be taken at his word, she was the first woman potter in Japan of any nationality.

Janet very much admired Hamada's mastery of poured glazes and she practised this decorating technique and used it herself for the rest of her life. She said that Bernard had thrown his hands up in horror at her brushwork and for that reason she was very glad to discover a completely new approach to decoration.

The ambience at Mashiko coupled with Hamada's working philosophy were as much of a revelation to Janet as were the technical skills she encountered. She went to Mashiko to learn pottery but found herself equally enthralled by every aspect of craftsmanship and the prevailing attitude to working which surrounded her wherever she looked. She was as interested to watch the carpenter as the potters. Hamada told her that she did not come to Japan to learn skill, saying that skill was cheap in Japan. He added that any potter in Mashiko village was more skilful than he was. This subtle distinction between facility and attitude was perhaps one of the most valuable lessons for Janet.

Travels in Japan with Bernard Leach

After a few weeks in Mashiko Janet wrote to Bernard saying, 'you mentioned there was some work I could do for you; please don't hesitate to send it to me, as I would be very glad to do it if I can.'[31]

Bernard replied explaining that he was still writing about his travels around the traditional country potteries and he needed to get his weekly entries typed up on the go for the editor of a Japanese magazine who had arranged to publish them in instalments. Then instead of sending his manuscripts to Janet, Bernard asked if she would bring her typewriter and come with him. Janet recognised this invitation as a unique opportunity to visit all the most interesting potteries with a very knowledgeable guide, and although it would mean leaving Mashiko and making no pots for a while, she accepted Bernard's offer. She knew their travels would be helped along by the fact that he spoke quite fluent, albeit slightly archaic, Meiji Japanese and it was also clear to her that his celebrity in Japan would smooth their way wherever they went. Thus Janet agreed to leave Mashiko and go with him to the ancient potteries including those in Kobe, Kyoto and Tamba.

Janet with Bernard, Tamba, 1954
Bernard decorating a plate using a bamboo slip trailer.
These slip trailers were unique to Tamba

A warm friendship had developed between Janet and Bernard when they first met at Black Mountain College two years earlier. Now while touring the potteries in rural Japan and exploring the Japanese countryside together their friendship developed into a strong mutual attraction. A friend of Yanagi, Mr Nakamura, owned the Kazanso Hotel in the mountains near Matsumoto, and it was here that Janet and Bernard enjoyed their first nights together, or as Bernard put it, 'during the hot months of July and August we had a wing to ourselves.'[32] Although Bernard was still legally married to his second wife Laurie, they had been separated for over five years and he had long since abandoned any thoughts of a reconciliation with her.

In Matsumoto Janet and Bernard were invited to visit a music school run by Shinichi Suzuki who was conducting a class of fourteen young violinists: girls and boys aged between five and thirteen, all of them extremely accomplished musicians. Janet and Bernard were both deeply impressed by their flawless performances of several Western classical compositions as well as some Japanese pieces. Then Suzuki asked the children to carry out random tasks such as counting the electric lights in the room, while they continued

to play their instruments. The fluency of their music was unaffected as they looked around and counted. Suzuki, whose methods became world famous, believed in teaching very young children to play an instrument by ear, just as they had learnt to speak. He felt that rather than merely developing proficiency with an instrument, playing music would nurture nobility of character. These children, none of whom had been considered musical, came from hard-working farming families living a tough existence in the mountains. They had started lessons with Suzuki from as young as three, and none of them had been older than eight when they took their first lesson. Janet found their playing, 'one of the most moving experiences'.

Janet typed the last instalment of Bernard's diary at the beginning of September 1954. Six years later these writings were collated and published as *A Potter in Japan*.

Bernard wrote, 'During those long weeks, I came to know Janet. I found her a great help in typing my book, and with delight discovered her sharing the Japan I loved. My friends became her friends; in Kyoto, my brother potter, Tomimoto, made her welcome, and gave much of his leisure time to her. I thought of a shared life, with Japan as a background, and I asked her to marry me. We began to plan a future somewhere in the neighbourhood of Kyoto

Kenkichi Tomimoto

Kenkichi Tomimoto with Janet in 1955

where Tomimoto lived, and which she had come to know better than I did. I felt we could be happy in that area of old Japanese culture.'[33]

Janet agreed to Bernard's proposal of marriage, and found herself looking forward to the future they were now quite unexpectedly planning to share in Japan. She wrote in her diary, 'With Leach everything is heightened, I love him dearly.'

In the late summer, Janet returned to Mashiko and the routine workshop tasks of filling press moulds and grinding the bases of freshly fired pots, while also taking any opportunities that arose to practise some throwing.

One day while Hamada and Janet were discussing her recent travels with Bernard, Hamada suggested that she might like to do exactly as he himself had done and spend some time working in one of the older traditional

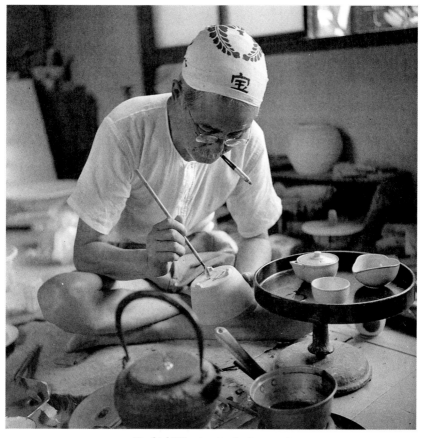

Kenkichi Tomimoto signing a pot

potteries. As she had been particularly attracted to the pots and the working environment in Tamba, one of the Six Ancient Kilns of Japan, arrangements were made for her to join Tanso Ichino's family workshop in Tachikui, a small village situated on the side of a long valley in Tamba.

Tamba

In December 1954, Janet moved up into the mountains of Tamba to live and work with the Ichino family. There were more than twenty kilns in Tachikui village, but as elsewhere in Tamba, the potters were also farmers who worked according to the seasons.

Tachikui, Tamba

Ichino house and yard, Tachikui

The following spring Janet photographed women planting rice
in paddy fields in Tachikui.

All three generations of the Ichino family welcomed Janet to their home of ten people. Grandmother Kumi Ichino was smoking a pipe as she came over to sit down next to her, and they all stayed up chatting and laughing together until late into the evening.

Although she was extremely glad of the warm reception, Janet felt slightly inhibited when she discovered she could not go out and explore the surrounding area on her own, but was always accompanied by at least one little boy, kindly sent along to be with her at all times to prevent her from getting lost. Here, as in Mashiko, she was amazed to find herself encircled by press photographers and reporters who had heard of her arrival and turned up to see her even in this remote mountainous region.

The abundance of kindness and goodwill bestowed on her by the Ichinos left her feeling 'nearly dead from hospitality', and she told Bernard, 'here there is an ample heart-felt warmth but I do miss privacy and a chair.'[34] Thirty years later, and with great feeling Janet said, 'The Ichinos are still my Japanese family, very special people.'[35]

Straight away on arriving in Tamba Janet was glad to be given necessary work to do, starting with an order for a batch of sake cups. She also found that right from the start she was free to work on her own pots. Although much of the Tamba pottery was glazed, she particularly admired the traditional, minimally glazed ware, and the way the local iron-rich clay responded to the intensity of the flames where they made direct contact with the surface of the pots as they were fired.

Janet noted the extremely practical nature of the local pottery. She found that Tamba was mainly a container-making place. There was no metal, glass or plastic for any containers when she arrived. To illustrate the breadth of the Tamba pottery output, as well as all the other items they produced, they not only made small sake bottles for domestic use, but also the enormous bulk containers for the sake-making industry.

Bernard wrote in *A Potter in Japan*, 'the Tamba pottery traditions go back twelve hundred years and are the oldest in Japan.'[36] He described Janet's life with the Ichinos, 'Here she had a wheel of her own, and a heated cushion which kept her partially warm during the bitter winter months. For over a year she endured, but enjoyed, the hard life washing her clothes in the one stream that runs down that twenty miles of valley, even in the winter when it was frozen over, and feeding on the same very limited diet … Janet did not speak much Japanese. I doubt if she had much more than a hundred words, but in spite of this she had an extraordinary capacity of understanding what was going on, and of making herself intelligible. She

became really loved in that valley where the inhabitants were mainly potters. It required courage to live alone as an alien in a village of five hundred people.'[37]

Janet flourished in the relaxed atmosphere of the Ichino family pottery, and gladly accepted an invitation to extend her stay. She never returned to work at Mashiko, although she came 'out of the hills' every six weeks or so when Hamada was firing a kiln. She never wanted to miss a Mashiko firing and Hamada let her know in good time when each one was planned. Janet's spoken Japanese improved a great deal in Tamba, so during her return visits to Mashiko, having acquired a subtler understanding of the nuances of Japanese conversation, she was able to get to know Hamada a lot better. While his kiln firings were under way he was relaxed and happy to give her his time, offering her much valuable advice.

Tamba in winter

Janet, Toshiko Ichino, Tanso Ichino, and Kazutaka Ikuta

Grandfather Ishimatsu Ichino, Janet, Takezo Ogami and Hiroyuki Ichino

Washing vegetables by the stream

Roof, mountain and laundry

Glazing pots

Glazing a large bowl

Slip trailed decoration at Tamba

Girls preparing wood bundles for the kiln

Janet's Description of Tamba

Any of the old Japanese potteries still in existence are a revelation to Western potters but the most outstanding ones are in the area known as Tamba. Their primitive roots are the most strongly preserved. Even to Japanese potters Tamba pottery is unique, its kilns and methods unknown elsewhere.

Hamada has taken much of his inspiration from old Tamba pots and he suggested I do my 'field work' in the village. It was incidental to me that it would be in the dead of winter, that the living was the most primitive in Japan and that not one word of English was spoken there. I had come to study pots and the best ones were in the central mountains approachable only from one direction, up the narrow winding valley from Osaka, not all that many miles but a hard four hours by train and an agile mountain goat type of bus.

The village of about forty potter families lies along the edge of a narrow valley of rice paddies. The mountains rise on both sides at a forty-five-degree angle and the thatch-covered roofs thrust themselves skywards at a similar pitch. The landscape is dramatic and the weather knows no temperance, be it rain, wind or snow. The bitter wind funnels down the mountain ridges. The people are small, the food is poor, and habits are spartan, but there is great pride in their survival and the survival of their heritage as one of the oldest potteries in Japan. Pottery has been made here consistently since ad500 and it is believed that there was a prior epoch of potters but little archaeological study has been done in Japan and this earlier period has yet to be verified.

That Tamba pottery has survived this long is not because of the availability of clay and wood, nor because of easily reached markets, but just because it has always been the way of life and changes are so slow as to be almost imperceptible. The heyday was in the tenth century when Kyoto was a flour-ishing capital. The pots were transported by foot over the crest of the moun-tain range. This rural pottery, carried to a great cultural centre, was cheap utilitarian ware, mainly sake bottles, pickle jars and huge pots for trees. The stark forms of these red clay Tamba pots pleased the tea masters of Kyoto and even today one can find a Tamba pot being used as a cherished water jar for tea. That their utilitarian work was found to be suitable for tea ceremonies has been the salvation of the Tamba potters.

Potters historically moved their home and kilns to the best clay beds and moved further along as the good clay became used up, but later they estab-lished permanent villages. In Tamba as in most of the rural potteries they are now obliged to use the poorer quality and less plastic clay left behind after centuries of selection. In Tamba the clay is especially bad but they have

evolved throwing techniques in accordance with the clay's limitations. Large and small pots alike must be thrown in two or three stages as the clay will not pull up nor open out as we might expect.

No two pots on a board are any more similar than two apples off a tree. After firing the colour of the pots varies widely due to an only semi-controlled atmosphere in the kiln (oxidation or reduction) and the wide range of firing temperature between 1200 and 1400°C. Little concern was given to this or to 'seconds' ... such was the law of nature and I was constantly aware that this attitude was the source of traditional Japanese wisdom, culture and custom in every sphere. In this village one could see it very clearly as life was stripped of all ruffles and icing.

The Ichino family who I lived with was one of the largest pottery-producing families in Tamba. What induced them to take in an unknown foreign woman, who would obviously be much trouble, I shall never know. It wouldn't happen with mountain folk in America or in isolated parts of England I'm sure.

Ichino kiln

Tamba kiln

Kiln packing

Janet removing a bung, to check the firing

Firing the Kiln in Tamba

In this description of the unusual firing methods of Tamba, Janet intersperses technical details with rich portrayals of the Tamba potters themselves, their humanity and their idiosyncratic mind set:

The most outstanding thing in Tamba is the kiln where the pots are put through their trial by fire. The Tamba potters' knowledge of fire is extensive but their method of firing is the most primitive I have ever encountered. In their daily life if they are cold they hover round a small charcoal fire, but never think of closing a door or using a fire to heat a room. It is the same with the kiln, wood is thrown in directly on top of the pots! I noticed this kind of thinking repeatedly. One goes to fire for heat, one never thinks of enclosing warmth.

Centuries of firing has led them to an understanding of what they are doing and why. Scientifically designed 'Kyoto type' kilns have been built in Tamba in an effort to 'enlighten' them, but these were soon discarded as inferior. This was not mere conservatism but rather they knew that their pots got much of their vitality from direct contact with the fire, wood and ash. The local government established a laboratory in their midst to educate them in the use of modern chemicals, electric kilns, slip-casting, scientific control etc. Fortunately their instincts were stronger than the good intentions of the government, so nothing changed.

From the sixth to the fifteenth centuries pottery was fired in a 'hole in the cliff' kind of kiln. The remains of these kilns still exist and there are stoneware pots with ash glazes dating from about ad1350. There are earlier shards around these kilns, indicating very early knowledge of ash as a glaze, developed from the incidental fusing of ash on to pots. These old cliff kilns were precursors of climbing kilns. The Tamba kiln today is only a slight refinement of this and was started around the sixteenth century with the arrival in Japan of the Korean potters' influence. The kiln in current use in Tamba is a half-circular tunnel built of clay instead of being dug out, which climbs 100 to 150 feet up the mountainside. Its angle of rise is two feet every twelve feet. The tunnel is around five feet wide inside at its base and about three feet high. Originally the pots were all packed from the fire mouth up the entire length. Gradually side openings were added every twelve feet or so for extra access, giving the impression of a snake with bulges at intervals. Each side opening is supported by two or three columns. The flow of heat is unrestrained and the flame rushes up the length of the kiln with amazing speed. There is no chimney, only a vertical end wall perforated with holes six inches across. There are small stoking holes along both sides of the kiln. The crudity of

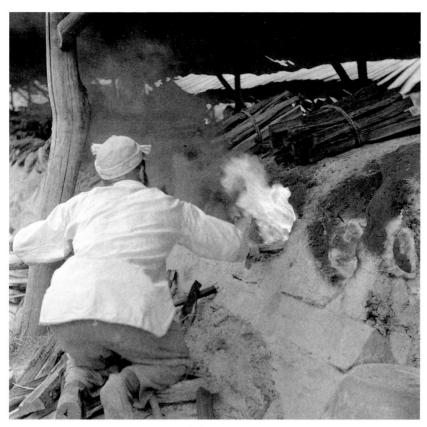

Side stoking

this kiln's construction is unbelievable. Built with homemade bricks, about five inches thick, basted with clay, it has a sculpted appearance, the outer surface coated in straw and clay. To my amazement the straw does not burn out. Huge stones line the sides, giving a wider foundation. The entire kiln is covered with a low-peaked shed protecting it from the elements and making one photograph of the whole thing impossible.

The older Japanese kilns were stacked without shelves or saggars. With remarkable ingenuity smaller pots were set into larger ones, making tall columns of pots. Most rural potteries making kitchenware continue to stack like this. Tamba does the same. The better pots are put into saggars but in Tamba this is not much of a refinement, as every saggar I saw at any of the twenty-two kilns was broken into at least two pieces after a few firings. This was due to the rapid heat rise and fast cooling. The saggars were fitted

together and wrapped around with rope each time they were used. This was regarded as the natural thing to do and I never saw one slip.

I became convinced as I watched the Tamba firings that they were breaking some of the laws we have made about temperature rise. I watched men poke small split pinewood sticks into a stoke hole and get 600°C heat-rise in a chamber in about two hours, while twelve foot away the following chamber was still almost black.

Firing an eight-chamber kiln starts in the evening and continues over the following day and night before reaching 1300 to 1400°C. The fire mouth is fed slowly at first. I have seen a woman putting a few sticks of wood in as she sat and did the family mending. After the first thirty-eight hours of this slow heating the temperature of the first chamber reaches about 850°C while the eighth chamber is still only about 75°C. At this point the fire is

Stoking the last chamber

rapidly increased and the temperature climbs to 1300°C in the next three hours. Another hour brings the temperature to its peak of 1400°C with the last chamber still only at about 150°C. Then the side stoking is begun by a man on either side of the kiln. For the next twelve hours they gradually work their way up the kiln, stoking each hole until it reaches temperature and moving on to the next stoke hole. Each chamber takes about an hour and a half to fire. There are ten pairs of stoke holes per chamber and the first chamber needs a little over an hour to stoke and the last one over two hours.

During the stoking flames burst from everywhere; the men usually wear broad- brimmed straw hats to protect their eyes from the heat and I wondered why these hats didn't catch fire. The firewood is about fourteen inches long but cannot be thrown into the kiln in the usual way. Space is so limited for the required amount of wood that it must be forced in, actually pushed against and between the pots. In a moment the stacks of pots are completely embedded in embers and a long iron poker is used to push the embers down to make room for more wood. Each man constantly uses a poker, pushing and spreading the embers and righting the occasional fallen pot. I once saw a man bend an entire tier of pots nearer to the stoke hole so he could reach in and pull out a glaze test. He straightened the tier, and later when the kiln was unpacked they were in perfect condition! In my early days in Tamba I had a

Side stoking

Smoke emerging from top chamber

large plate sitting on top of a bung of saggars with its rim only a few inches from the stoke hole. As I watched it fill up with embers I consoled myself with knowing I had enjoyed making it, as I was convinced the glazed surface would be completely ruined, but it came out without any battle scars and the glaze was better for the additional ash.

The kiln has little heat-retaining capacity. It's like a wind tunnel. The first chamber begins cooling rapidly even though the stoke holes are sealed. By the time the third chamber is being stoked the first chamber has dropped to about 600°C. Mr Leach tells the story of similar but larger Korean kilns where they were unpacking the cooled first chamber while continuing to fire the subsequent ones. I can see how this is possible in a kiln of fifteen or more chambers. The temperature rise of the last chamber, the eighth, is a revelation. It is hardly affected by the firing of the first four chambers, only reaching about 200°C. The fifth chamber stoking brings it up another fifty degrees, but when the sixth chamber is stoked the last chamber rises sharply from 250 to 600°C. Stoking the seventh chamber brings it to 700. After two and a half hours of progressive side stoking the last chamber reaches 1300°C. The flames now burst from the openings at the end of the last chamber. It is a beautiful sight. After the final stoking the holes are sealed by throwing clay at them.

During every firing I had the impression that this dragon spitting fire from all its apertures was not fully tamed. After every firing, the men who had controlled the kiln just enough for their purposes bowed to it and said, 'Thank you.'

Janet unloading fired pots

Fired pots

Grandmother Kumi Ichino stringing pots for transport

St Ives

By November 1954, Bernard had been away from St Ives for over two years, having gone straight back to Japan after the American seminars. It was around this time that he began to receive disturbing reports of low morale back at the Leach Pottery, with the workforce concerned about a lack of clear direction and feeling that for too long they had been abandoned to their own devices. Bernard realised he had no option but to return to St Ives, just as soon as he had completed a long-planned visit to the Bahá'í centre in Israel.

His interest in the Bahá'í faith had grown through his friendship with gay American painter Mark Tobey, whom Bernard had met at Dartington Hall. Tobey's free and honest outlook on life, coupled with his religious beliefs, had intrigued Bernard to such an extent that he eventually became a Bahá'í himself. Put very briefly, Bahá'í is an offshoot of Islam, preaching the essential unity of humanity, and viewing all the major religions as manifestations of the same deity.

Bernard knew that once he was back in St Ives he would not only be confronted by all the practical problems concerning the pottery, but he would also be facing the mounting complexities surrounding his divorce from Laurie, which he was now keen to hurry along so that he could marry again. He knew that none of these difficulties could be ignored for very much longer.

Somewhat reluctantly he returned to Cornwall while Janet continued to enjoy her life in Tamba, unaware of the gravity of the issues Bernard was dealing with in St Ives, and happy in the assumption that they would soon be reunited to set up their home and pottery in Japan. They wrote to each other regularly to discuss their plans, even weighing up various ideas they had for furnishing their future Japanese home. In one of her letters Janet mentioned an idea they had previously discussed, of marrying in Hong Kong, to give their marriage legal recognition in Britain, but she had found out that regardless of age, parental consent was required in order to do this. She told Bernard, who was in his sixties, that he would have to get permission to marry from his step-mother! She added light-heartedly that, as for herself, 'I can beat my parents over the head and get the necessary paper or whatever, based on their not understanding what it's all about.'[38]

At first their letters focussed on where they might live and build their kiln and workshop once they were married, with possibilities including somewhere in Tomimoto's area near Kyoto, or around Abiko where Yanagi lived. These early letters were cheerful and full of news with detailed discussions of their plans. In a carefree tone Janet wrote, 'I love you even if you do wake at dawn bright and cheery. I've always hated that type.'[39]

While Bernard was trying to deal with the situation in St Ives, Janet continued to divide her time as before, making pots at the Ichinos, and travelling by train or bus to visit other pottery villages. She was keen to explore the ruins of ancient cliff kilns, the early precursors of contemporary climbing kilns. Her interest had been kindled when she came across shards of pottery scattered on the ground in their vicinity. These were the broken remnants of pots which had been fired hundreds of years earlier, and left lying around. They were thickly coated in an ash glaze. Since the kilns were 'merely' large holes excavated in natural banks or cliffs they were extremely damp, which necessitated extra-long firings of many days' duration just to dry out the walls of the kiln itself before even beginning to climb to peak maturing temperature. These extremely long firings led to the production of unusually copious amounts of ash turning to glaze on the uppermost surfaces of the pots.

Just before Bernard's proposal of marriage had completely overturned her long-held plans, Janet had written to the Guggenheim Memorial Foundation with an application for a Fellowship regarding her ambition to spend two or three more years exploring all that she could of traditional Japanese potteries. In it she wrote, 'Most of the potteries I plan to see and work in are very remote mountain hamlets where the pottery skills have been in existence since the Korean potter-prisoners were brought to Japan in 1600. In some places the potteries were there before that. Their craft has remained uncontaminated by industrialism or the Japanese export business. The villages are all so remote that not even the Japanese know much of their location, though their pots are very well known in the major cities as they are sold through the network of folk-craft shops. There are about fifty of these villages in Japan, where particular forms, glazes and firing techniques are passed down through the generations. Glazes are a simple mix of local stone, local clay, wood ash and rice-straw ash.'[40]

While settling deeper into Japanese life Janet was meeting some of Bernard's Bahá'í friends of various nationalities. Although she was beginning to wonder if she might eventually be able to commit to Bahá'í, as was Bernard's fervent hope, her letters to him also clearly show her airing her suspicions regarding organisations of any kind, religious or artistic.

However, by July Bernard was obliged to explain to Janet that the situation in St Ives was proving very hard to sort out, and the tone of their correspondence became tinged with real anxiety.

Bernard and his son David had for a long time been dealing with their seemingly intractable differences concerning the pottery business, and the details of their legally drafted partnership, including disagreements over the ownership of the workshop and Pottery Cottage buildings. Their problems

were hugely exacerbated by equally long-running financial worries, at a time when the survival of the pottery relied entirely on pot sales, the most lucrative source being Bernard's individual, exhibition pots.

David, with a growing family to support and another child on the way, had already found it necessary to spend extensive periods working away from St Ives, mostly teaching pottery, or helping others to set up potteries elsewhere. In effect David no longer worked at the Leach Pottery, although he returned from time to time to help out, until finally he left St Ives for good in 1955, to set up a family home with a workshop and kiln in South Devon at Lowerdown, Bovey Tracey.

Bernard acknowledged that it was probably good for David to 'get out from my shadow'[41], and I think he may well have been right because even fifty years later, in 2004, David told me with a characteristically warm smile, 'people say I'm very derivative of my father' and all I could say was, 'David, you're ninety-three!'

In 1955, the same year that David left St Ives, his younger brother Michael also moved away with his young family to set up his own workshop and kiln at Yelland in North Devon. David and Michael were both highly skilled potters, but now they were definitely out of the running regarding the future management of the Leach Pottery.

While Bernard was trying to sort out the pottery, and the many troubling complications standing between him and his divorce from Laurie, he received further bad news. His first wife Muriel had become seriously ill, and it soon became clear that she was not going to recover. Later that summer her health deteriorated and in July she died. After Muriel's death Bernard was caught up in an emotional turmoil of sorrow and guilt.

The youngest of Bernard and Muriel's five children were twin daughters, Jessamine and Betty, who were born in 1920. Betty had been diagnosed with cerebral palsy as an infant, and consequently had never moved away from Muriel, who cared for her all her life. Betty was thirty-five when Muriel died and now she was put into a care home, which added to Bernard's painful feelings of self-recrimination.

Bernard had always known how much he had hurt Muriel when he left her for Laurie, and now he found himself back at the pottery with all of its seemingly insurmountable problems, in the uncomfortable position of preparing to carry Muriel's coffin at her funeral while trying to extricate himself from his marriage to Laurie, in order to free himself up to marry Janet. He decided that under the current particularly unhappy and tumultuous circumstances, his family didn't really need to know about Janet just yet.

He had also kept the details of his personal troubles in Cornwall from Janet, but gradually the gravity of his situation began to dawn on her, and she started

to doubt whether their plans to live together in Japan would ever come to fruition. Furthermore she questioned if it was really in the interests of either of them to actually get married, or whether it might be better all round to keep their relationship informal. It now occurred to her for the first time that she might have to choose whether to continue the life she was enjoying so much in Japan but on her own, or leave Japan to join Bernard in St Ives, a place unknown to her, in a country she had never visited, where it was becoming clearer that in all likelihood Bernard would be obliged to stay. Janet had never visited any part of Europe, and had no means of judging what life in St Ives might be like, apart from what Bernard had told her in his distress, and although she was eager to be with him, she also wanted to explore Japan further and had absolutely no desire to leave it behind.

Janet's Travels in Japan

From her base in Tachikui, Janet's explorations took her to Naeshirogawa, Onda, Koishibara, Matsue, Kobe, Osaka, Bizen and Horikoshi, a coastal area beneath hills surrounding an inlet on the north coast, with kilns all along the bay, where she photographed pots being neatly stacked into boats for transportation to Kyushu. Most of the pots made there were fishing jars, used for processing and storing fish.

Horikoshi

Horikoshi

Bizen

In Naeshirogawa Janet saw teapot spouts being made, pulled up around a tapered stick on the wheel. She resorted to this method in 1997, on the very last batch of pots she ever made, when she threw tall, very thin necks on small vases, around a pencil. However, it was what she saw one afternoon while she was visiting Bizen, during a kiln packing, that particularly caught her interest, prompting her to ask if she could come back to see the whole process through for the next firing.

In the autumn she visited Bizen again for the ten days it took to pack and fire the kiln, and returned for a second visit a couple of days after the firing was completed, to watch the unpacking of the fired pots. It was there in Bizen, one of the Six Ancient Kilns of Japan, that Janet was intrigued to observe their apparently haphazard kiln packing, requiring no kiln furniture at all.

The asymmetrically thrown and roughly-finished pots seemed to be piled up anyhow. They lay on their sides on top of each other among pieces of wood and rice straw, their decoration left entirely to the wood ash which landed on them from the stoking and from where the direct flame had been concentrated on the surface, melting the iron content of the clay. There was no additional surface glaze. The packing was not in fact as random as it seemed to Janet. A resist of clay and sand mixed together was carefully placed to separate the pots and stop the ash from fusing them together in the firing. Tiny stones, deliberately left in the clay, exploded in the intense heat of the kiln, causing small raised spots with cracks radiating from them. Pots from these firings had a part-oxidised, part-reduced cratered surface of various soft colours. Witnessing these Bizen firings was pivotal in Janet's career, providing her with arguably the most informative experiences of her time in Japan. These Bizen firings influenced her approach to pot-making, kiln packing and firing ever after.

Janet was struck by the warm character of the master potter of Bizen, Toyo Kaneshige. He was a Living National Treasure, a Japanese honour awarded to those whose work perpetuated traditional art forms which would otherwise be in danger of dying out. Kaneshige was generous with his time, and welcomed Janet to stay at the pottery during all the activities surrounding the kiln firing, which was stoked continuously for seven days, four days more than was usual.

When Janet left Bizen she brought with her a pot of Kaneshige's which she had particularly admired, a thrown bottle, beaten into an oval, with a neck added later.

Toyo Kaneshige

In 1982 Janet spoke of her good fortune to have been in Japan when Toyo Kaneshige, Kenkichi Tomimoto, Shōji Hamada and Kanjiro Kawai were all in their prime, saying, 'They are all dead now, but I could just go around and visit them all. I was welcome everywhere, they weren't sick of foreigners by then. That opportunity doesn't exist today.'[42]

Loading kiln, Bizen

Water jar, Bizen

Wall construction, Bizen

In October 1954, still unsure of where her future lay, Janet rented a room in the Shokokuji Zen Buddhist Temple in Kyoto, presided over by Sohaku Ogata. Here she had a quiet place to stay, and to store pots she had made at the Ichinos, as well as pots she had bought during her travels away from Tamba. The tranquil atmosphere of the temple gave her somewhere to relax and collect her thoughts while she struggled with her dilemma.

For a long time Bernard had planned to take up permanent residence in Japan although Yanagi had warned him that if he did settle there permanently he might risk losing the high status which had always been afforded him as an occasional, honoured guest. Much more straightforwardly, Bernard's deeply trusted and practical old friend Hamada, who had established the Leach Pottery with him at the very beginning, and who was partly aware of the current troubles surrounding it, advised him to stay in St Ives, where he was clearly needed, and sort out his own workshop. On hearing this, Janet wondered why Bernard relied so heavily on his friends' advice but it seems he felt the need for their approval, and thus the decision was more or less made for him and he agreed to stay and focus on the pottery at St Ives.

CHAPTER 4 **Janet's Arrival in St Ives**

After much soul-searching Janet decided that she would forego her life in Japan and join Bernard in St Ives. She made arrangements to travel to England aboard the SS *Ascanius*. She told Bernard, 'I am quite dizzy from the change of continents.'[43]

As the time approached for her to leave Japan she became increasingly uneasy. She realised she would be arriving in St Ives during the Christmas holidays with the Leach family close by, all very much shaken by Muriel's death, and meanwhile Bernard's divorce from Laurie was still pending. With faltering nerve, hoping to reacquaint herself with him in private before facing all the difficulties in St Ives, Janet asked Bernard if he would come to meet her at one of her scheduled ports of call in the Mediterranean, from where the two of them could travel on to England together. She suggested they might meet in Egypt, Greece or Italy. One idea she had, perhaps running for cover, was for the two of them to meet in Cairo where they might be able to work with an old student of Bernard's, an Egyptian potter whom Bernard had liked very much, or possibly they could join Michael Cardew in Nigeria and work with him. Her suggestions came to nothing since Bernard was fully engaged in the situation at home, and she finally arrived in England on her own, to be met by Bernard in London.

When Lucie Rie heard about Janet's imminent arrival she wrote to Bernard from London offering her a place to stay before catching the train down to Cornwall. Bernard received Janet's final letter written to him from Japan saying, 'It's been a beautiful but sad week nibbling at experiences I would have wanted to linger in. I am overawed by all the extreme kindness here, real friendship, and love. I came to Japan empty handed, I took from everyone and I depart loaded with gifts! I will let Lucie Rie know when I'm getting to London.'[44]

In January 1956, Janet finally arrived in St Ives and moved into lodgings close to the pottery for the sake of appearances, while Bernard waited for two more months for his divorce to come through. A few days after his divorce was finally granted Janet and Bernard were married in the register office in Penzance, and later that year in August they had a Bahá'í marriage ceremony as well.

Managing the Leach Pottery

For both Janet and Bernard the reality of married life at the Leach Pottery was a far cry from the life they had so happily anticipated spending together in Japan. They had been separated for over a year and were looking forward to

their eventual reunion, but once Janet got to St Ives she found that Bernard's troubles had left him fretting, worried to an extent she had never seen in him before. Beside his very real practical and personal problems, he was also dealing with a blow to his ego. Back in Cornwall he was being treated with far less deference than he had been used to in Japan, and this sudden loss of status had diminished his confidence.

Bernard was back in charge of the aesthetic aspect of the Leach Pottery production, but the pottery still needed a manager, so immediately on Janet's arrival he put her in charge of the workshop and the output of the potters, some of whom had worked there for many years. They included Kenneth Quick who had been there for ten years, and Bill Marshall who had spent nearly twenty years in the workshop, ever since he left school at fourteen. Both Bill and Kenneth were highly-skilled throwers who knew the running of the pottery inside out, as did others working there.

It was an almost impossible position for Janet, a foreign incomer who had never planned a life in Cornwall, whose authority was suddenly imposed on the workforce. She was an independent-minded potter, working in a completely different way from Bernard and the Leach aesthetic, who, in her own

Janet and Bernard at the Leach Pottery

words, made 'funny pots'. Every bit as bad, she was a woman. Bernard seems to have failed to foresee the difficulties that would inevitably arise if roles were not extremely carefully allocated and defined, and indeed resentments did arise, rumbling from time to time beneath a veneer of grudging respect for Janet and the improvements she brought to the pottery. It must have been a lonely time for her when she first arrived as a stranger, with Bernard the only person she knew.

In spite of these difficulties, Janet got into her stride as manager of the pottery and was soon organising the daily running of the workshop, supervising the students, and discovering their individual strengths and weaknesses to make the best of their particular talents. She considered herself 'the business brain', establishing new, much-needed sales outlets, and suggesting changes in the design of the standard-ware range, which brought it up to date and made it more practical. She also organised deliveries of a more robust, pleasingly-textured stoneware clay body which she developed in collaboration with the Doble family at Newdowns Sand and Clay Pits on the cliffs near St Agnes. This clay is still used every day at the Leach Pottery. The changes brought about by Janet's fresh approach were met with general approval. She also found time to make her own pots, though once again, not nearly as much as she would have liked. Her workload really started to pile up when she found she was required to act as Bernard's housekeeper and personal secretary, and to take charge of the pottery office as well.

In his introduction to *Bernard Leach, Hamada and their Circle* Michael Webb wrote of Bernard Leach, 'On his return to St Ives, he went through a most anxious period until Janet Darnell ... became manager in 1956 and instituted a regime essential to save the pottery from insolvency.'[45]

Being Bernard's third and much younger wife undoubtedly caused consternation within his family, and Janet also met with some scepticism in St Ives about her motives in marrying Bernard who was thirty years her senior. Remarkably, but characteristically, she appears once again to have shrugged off any negativity she came up against, feeling no need to acknowledge it nor to justify her position.

It soon became clear to Janet that her needs as a working potter were always going to be subordinated to the needs of the Leach Pottery. Her personal working time was often limited to the evenings and weekends. Initially she made her pots in the main workshop with the other potters, having turned down Bernard's offer to share his personal workshop upstairs because she felt his influence was too strong, and his whole aesthetic different from hers. She found he could be a bit too quick to comment on her pots, and she wanted

to complete them before they were subjected to his appraisal. In many ways Bernard was typical of men of his generation and doesn't seem to have realised what vital importance Janet attached to her work as a potter, nor the determination with which she intended to pursue her own vocational path as she always had. Once they were married it became clear, as several of his letters attest, that he fully expected her to drop everything whenever he asked her to perform domestic tasks for him, such as ironing his clothes, sewing on lost buttons or darning his socks, as well as preparing regular meals at fixed times every day, just as Muriel had done while she was also caring for their five children.

In his personal relationships Bernard was particularly torn between the apparently irreconcilable attractions of adventure and security. While he seems to have wanted a wife to charm and challenge him with her independent spirit, he also wanted her to be a compliant and reliable housekeeper. He was enchanted by the free-spirited nature of Laurie Cookes for whom he left Muriel, and then after his marriage to Laurie foundered, he was once again entranced by Janet's independence and strength of character. However, when first Laurie and then Janet became his wife, each of these relationships suffered under his expectation that once they were married to him, they would buckle down and conform to his ideas, including his faith in the Bahá'í religion which was an increasingly important part of his life. Janet had sincerely tried to understand and assimilate the ideas underlying Bahá'í, and had even agreed to the Bahá'í marriage ceremony for Bernard's sake, but as she came to know it better she found Bahá'í as prescriptive and proscriptive as the Methodism of her Texas childhood, and entirely lacking in the elements of intellectual freedom and enquiry which had first attracted her to the Steiner philosophy back in New York. The Bahá'í organisation was too hierarchical for her liking, and when all else was said and done, too much of a club, with rules.

Janet had intended to keep her maiden name, but Bernard asked if the name 'Leach' wasn't good enough for her. So, not wanting to offend him, she was persuaded to take his name. Then while he was away on a visit to Japan he overstepped the mark by addressing a letter to her as 'Mrs Bernard Leach', whereupon she replied, 'Please address me as Janet Leach, I don't object to losing one name in marriage, but I do protest at losing all identity.'[46]

Although Janet recognised the obvious advantages in the Leach surname, she had assumed she would keep her maiden name partly because it was her own, and partly because she could see potential drawbacks in taking Bernard's. She knew that if she took the celebrated Leach name she could never

Janet throwing in the workshop at the Leach Pottery

be certain in her own mind, nor demonstrate to anyone else, the extent to which she had arrived at whatever her eventual professional status might be, on the strength of her work alone.

In the early 1960s Janet and Bernard each bought newly-built flats at Barnaloft overlooking Porthmeor Beach in St Ives. Janet also bought Anchor House just off Fore Street in the town to accommodate visiting students during their time working at the Leach Pottery.

When Bernard was not away on his numerous lecture tours, Janet and he were spending both day and night at the pottery. They were living and working in the same place under the almost incessant and somewhat suffocating scrutiny of the workforce, so after nearly eight years of marriage they agreed to give each other more breathing space. Bernard moved down to

Slab pot, black stoneware, white glaze pour

Janet's stamp on porcelain
In a salute to the Threefold Farm ideal of integrating head, heart and hand,
Janet designed her pottery stamp as a triangle containing her initials.

Barnaloft to concentrate on his writings, while Janet continued to live up at the pottery running the workshop and making her own pots.

While each of them now maintained their own separate living and working quarters, they recognised the importance of treating each other with civility and respect. Their correspondence shows that the problems between them were largely caused by a lack of clarity over their allotted responsibilities, and the fair division of hard-won pottery income. These same issues had once blighted Bernard's and David's relationship. It would seem that in St Ives during the 1950s and 60s, although house prices were relatively affordable, money was otherwise always problematic.

Exhibition poster, Tokyo 1967

One day Bernard was collared in the street to be told of a rumoured affair between Janet and another woman. Whatever the truth, since an affair was never openly acknowledged, the plain facts are impossible to extract from the gossip. The arts crowd down in St Ives were well-known for their alcohol-fuelled parties, and rumours of their antics perpetually swirled among them and around the town.

In Sven Berlin's *The Dark Monarch* he says of St Ives, 'no one could live in the town for more than a week without being gutted like a herring and spread out in the sun for all to see.'[47] He describes a drastically worse fate for those who stayed longer.

In 1969 Janet returned to Tamba where she spent two weeks making a batch of pots in the local very iron-rich clay, which were fired unglazed, leaving traces of ash on the dark red surface. These pots were exhibited in the Osaka Daimaru.

During this trip to the Ichinos, Janet suggested their eldest son Shigeyoshi might like to come to the Leach Pottery for two or three years to experience a different part of the world. As a very accomplished potter he would contribute a great deal to the output of the workshop, and in return, he could learn how to pull and apply European-style handles for jugs and cups, a skill he was keen to acquire, as ladles are used instead of jugs in Japan, and Japanese tea bowls have no handles. His family were concerned about losing him and his labour for such an extended period, but in the end they agreed to let him go, thinking the experience would ultimately benefit him and the Ichino pottery, which proved to be the case.

Shigeko Ichino, Shigeyoshi's wife, said that after Janet left their pottery in Tachikui and went to Cornwall to marry Bernard Leach, her invitation to Shigeyoshi to travel to St Ives over ten years later had a profound impact on their lives, leading eventually to international recognition for the Ichino pottery. She said, 'If Janet hadn't made that kind offer our lives would have remained quite ordinary. It's all thanks to Janet. Shigeyoshi having worked with a world-famous man; that was huge.' Shigeko later joined Shigeyoshi in St Ives and has fond memories of Janet's warm welcome.

Shigeyoshi was very well-liked amongst the workforce at the Leach Pottery. This was in spite of the fact that he threw pots so much faster than the resident crew that, according to John Bedding who was working alongside him, he showed them all up. Janet called him 'Shingei' and from then on he was always known by that name at the Leach Pottery. When he finally returned to Tamba after three years in St Ives he was missed both as a potter and as a friend. In 1981 the Amalgam Gallery in Barnes held a successful joint exhibition of Shigeyoshi's and Janet's pots.

Pot made by Janet on a return visit to Tamba 1969, h. 15cm

Pot made by Janet on a return visit to Tamba 1969, h. 14.5cm

Pots made by Janet on a return visit to Tamba 1969,
h. 16cm and 14cm

Janet and Shigeyoshi Ichino, Tamba 1969

In the mid-1970s, with Bernard's agreement, Janet organised the construction of a good-sized wooden building beside the stream for a pottery showroom, and converted the old showroom in Pottery Cottage into her own personal workshop with space for the two Japanese kick wheels she had acquired: one from Mashiko, and one that Shigeyoshi had brought from Tamba to use at the Leach Pottery, and left behind for her when he returned to Japan.

She used one of these wheels for clay stained with iron or manganese dioxide wedged into it, for a red or black body, and the other was kept clean for white porcelain, uncontaminated by colouring oxides. By now she had mastered these wheels, with their lack of momentum, by using the coil and throw technique that she had learnt in Tamba from the Ichinos. This slower method allowed her to bring softer shapes to her pots. She referred to the most loosely thrown of these as her 'baggy pots'.

Janet always used high-firing stoneware, or porcelain. As well as oxides added to colour the stoneware, she sometimes wedged large pieces of molochite into the porcelain to strengthen it, roughen its texture, and give it a more robust appearance. She rolled out the grogged porcelain to make slab pieces since the grog made it far too sharp to throw. Sometimes she used these porcelain slabs to fill press moulds, later adding lugs or feet. The porcelain pots were almost always glazed in pale celadon or white, and usually had a slash of black glaze poured across each surface.

Grogged porcelain pot

Grogged porcelain pots

Janet often squashed her red stoneware pots into irregular shapes or decorated them by beating them on each side with a roughly broken piece of wood, making irregular marks. These decorative dents also had the practical purpose of holding back the free-flowing limestone or ash glaze, keeping it from running too far down the outside of the pot as it was fired.

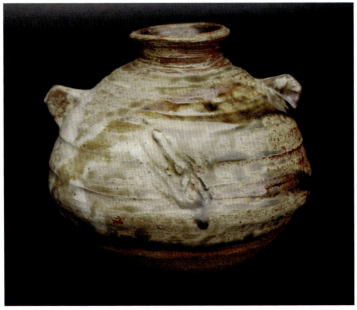

Janet's 'baggy pot'

She was aiming to achieve a similar surface quality on her pots fired at the Leach Pottery as that produced in the very large wood-fired kilns of the Japanese country potteries, epitomised by Toyo Kaneshige's at Bizen.

In the early 1960s she built a large single-chambered kiln behind the climbing kiln at the Leach Pottery. This kiln was built a few years before natural gas from the North Sea was piped to St Ives and was fired with oil and wood. Although Janet fired it many times, she lamented it could not be more often, saying, 'It's not possible to be a wood-firing potter more than occasionally in St Ives ... there are no trees!'[1] She also built a large oil-fired kiln for more frequent and much less smoky firings than was possible in the climbing kiln. Later, when piped gas arrived in St Ives, she replaced this oil-fired kiln with one of a similar size, fired with gas, and she also bought a very small gas-fired Laser kiln which she packed with small pots piled up inside a saggar.

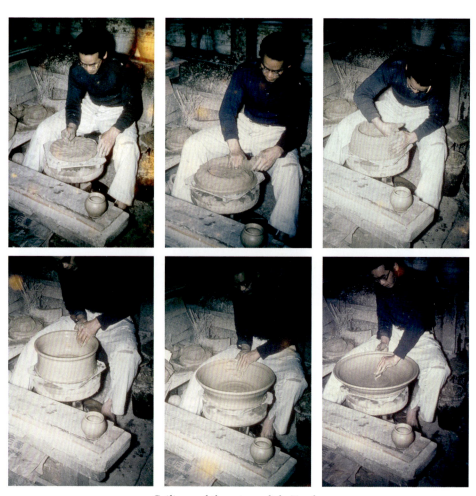

Coiling and throwing a dish, Tamba

Probate photograph of Janet's old Tamba pot

Iga ware

The surface textures of these Iga pots epitomise the qualities that inspired Janet's work. They were the result of very carefully packed and stoked firings, to 1500°C, using no glaze, but allowing the impurities and tiny stones in the clay body to emerge from the clay, and accumulations of ash to fall on to the pot from the pine stoking wood. Each Iga firing contained about 300 pieces and a successful firing yielded about five or ten good finished pieces. Edo period Iga ware was said to have been fired ten to thirteen times to achieve the special cratered and fissured surface effect beloved of Japanese tea masters and Janet alike. She compared these rugged pots to what she scathingly called 'blue' pottery which she characterised as prosaic, uninspiring and easy to sell. She quoted Bernard's tongue in cheek advice to potters: if your work isn't selling 'make it blue.'

In 1971, Janet wrote an article for *Ceramic Review* describing the development of the Leach Pottery:

The Leach Pottery ... Fifty One Years Old

Traditional Japanese potteries were started on clay banks with fuel and nearby markets available, but when the clay ran out or the market diminished such potteries collapsed or moved elsewhere. When Bernard Leach returned from Japan in 1920 to start a pottery in England, he did not follow the dictates of the tradition he so greatly emulates. He came to St Ives because a kind, wealthy woman was making an effort to introduce hand crafts into an area which had no previous tradition or inclination in this direction. By making this decision to establish himself in St Ives he intuitively set a pattern for twentieth-century artist craftsmen to 'live where you can <u>live</u>'. When he settled here this area was isolated from the cultural impulses of the land, it was extremely poverty-stricken as the tin mines were closing down and the fish no longer came in large numbers. The beautiful china clays nearby were too pure and lacking the subtleties he wanted, only a few local materials were of any use to him. How many studio potters today have chosen to work in the industrial North, rich with exciting fireclays and stone-glaze materials? He built the first oriental wood-fired climbing kiln to exist in the western hemisphere, in an area which had virtually no trees, and yet, because he is Bernard Leach, and because this area has grown as a vital artist community of which crafts are a part, all of us survive and it is an area in which we can <u>live</u> even now.

Originally he bought a narrow wedge of land between a stream and a main road, surrounded by large farms, and considered to be a quarter of a mile out of town. By now we have a council estate on one side and housing development on the other. Recently an American potter friend drove by several times, searching for the pottery; her impression from Bernard's lectures and books was that we were in the quiet country. The highly-coloured Esso station across the road prevented her from recognising us. We have plans to rebuild our outbuildings and showroom, and we are doing considerable landscaping. We are an oasis between 'Car Wash 2 shillings' and illuminated bed and breakfast signs.

The changes and growth within the pottery have been as wide and varied as those of the area. The original workshop was a granite structure built by the last of the granite builders (not cut granite). There is a space in our glazing area where we can say 'Hamada slept here, and also Michael Cardew' and I don't know how many others. It was conceived as an artist's studio, more than a workshop. There's a lovely old photograph of Bernard and Hamada

sitting round the fireplace having dinner which has been cooked there. Imagine a factory inspector's reaction to that today! Those times of avant-garde stoneware, raku and slipware, with muted colours imposed on a black area, plus international Depression, were not happy ones economically, but Bernard turned inwards and made some of his finest pots. He lived in his aura of Japanese life and shipped his best pots to Japan.

Later, David (his eldest son) joined him and sometime later Bill Marshall was hired as a fourteen-year-old school-leaver. David had recognised quite young that his father needed help both technically and with organisation. Gradually the standard-ware catalogue evolved to where it now contains over fifty pieces. This broadening of the concept to that of a hand pottery workshop with assistants making repeat oven-to-table ware which could be ordered by post, and which was moderate in price, was happening from the late 1930s until the early 1950s. A clay room was added on the back and an additional upstairs room was built as Bernard's private studio. With the increased number of firings a gradual transition to oil–firing for the kiln was vital. But this is history.

By the time I arrived in 1956 David and Michael Leach had started their own potteries in Devon. There was a trained group here, mostly Cornish, mostly apprenticed, with no previous art education. They were proud of their abilities and successes with the high level of the standard-ware. Slipware had been abandoned and all pots were reduction stoneware or porcelain. Pottery for Use was the motto: I privately called it a stew pot mentality. Bernard and I decided at this point not to take any more local apprentices, though Bill Marshall and Kenneth Quick were making very good pots on their own.

We decided instead to take a series of more advanced young potters, most of them to stay for two years. During this time we have had four Americans, five Canadians, three New Zealanders, four Australians, three Indians, two French, one Belgian, one Danish and a good number of English. In 1957 we brought Atsuya Hamada over for two years, and in 1969 we brought 'Shingei' Ichino from Tamba for a three-year period. We developed a programme of encouraging individual pots by providing a separate kiln where they could function outside of existing orders and standard kiln firings if they chose. This was a very rich time, with Bernard having weekly coffee evenings to discuss some type of pottery or technique, or brush sessions, etc. Every article on the catalogue was reassessed and many were redesigned. The problem of the balance between the individual development of the potter, individual pot making, the necessary work routine and standard-ware throwing was almost a daily preoccupation. It is, even today, a constant juggle and swing.

We believe in the validity of repeat throwing of utility ware for many reasons. We can teach a young potter to throw a pre-determined shape and permit him a wide latitude for exploration within that shape. As his skill and perception develops, we can pay him a small wage for the pots he makes and he, at the same time, is growing. He must keep the image of making each batch of pots better than the batch before, although he knows that by the catalogue they will sell for the same price. While the potter is making a hundred mugs he must always remember that one person is going to buy and use one mug.

Having the catalogue permits us to maintain a reasonable wage for the crew. But the catalogue itself imposes a discipline upon us. We must make what is ordered and meet delivery dates. The young potters quickly learn to make pots every day. The kilns must be fired and the orders must go out. All of us must do our jobs. I must do the post, visitors, telephone, organisation etc., with a very efficient secretary who saves our lives, and the potters must make what is ordered or needed to balance the kiln, or mix clay and glaze. The place puts its demands and standards of work upon us and none of us are free.

Bernard, at eighty-four, takes less notice of the daily responsibilities of the workshop, but he orbits within it. He works half days throwing intensively. We depend on Bill Marshall to shepherd the basic shapes of the standard-ware and to teach the young the shapes, but if someone goes 'off' on a shape it is glaringly obvious to us all. I prefer to start most of my pots over the weekend, and once they are begun I can find the time to finish them during the week with its constant interruptions. Several of our young potters stayed on and we aren't taking as many new students as before.

Our records for 1970 show that we made over 15,000 pieces of standard-ware which varies in price between fourteen new pence to two pound fifty wholesale as the most expensive catalogue repeat item. I do not know the actual number of individual pots fired in the various kilns, but I estimate it to be between 4,000 and 5,000. When we fired the climbing kiln only, we maintained a three-weekly firing schedule and averaged eighteen or nineteen firings a year. A few years ago I built a single-chamber kiln about five foot by five foot by five foot stacking area. We fire this with oil only, and get no offensive smoke. We only fired the climbing kiln twice last year because of the smoke problem. We have no intention of discontinuing its use, but it might be wiser to wait until gas comes into our area. The new kiln is a little larger than one chamber of the climbing kiln. We fire it twice a month and get about the same number of pots per annum. To fire the large kiln we need at least four experienced potters and the workshop is totally disrupted, while the new kiln

can be stacked and fired quietly and with ease by one man and the others can get on with their pots.

I also have a three-cubic-foot kiln that I am very fond of for certain effects. Any of the potters are welcome to use it and there is also a small salt kiln built of old bricks by a former student. Thus we are often several potteries within a pottery. Each potter must be allowed and encouraged to 'do his own thing', to develop his individual expression in pots alongside development in throwing standard-ware. We feel that this balance is the most important thing in the pottery. Too much concentration on individual pots or too much digging in to standard pots would be detrimental to the workshop as a whole, and detrimental to those involved. The pottery is never locked. All have studio privileges after five in the evening and at weekends. They have their own clay and glaze mixes. If they make their own pots in their own time we buy them and sell them in our showroom or shops, with a name credit.

Bernard prices all the individual pots and it is very interesting to watch them compare prices after he has decided on the price of each. Why did he price one at fifty new pence and another at five pounds? Although Bernard does criticise and talk to them about their pots while pricing them, I think the most important teaching happens when they are trying to see for themselves what Bernard saw. Actually we rarely discuss pots during the working day, because we are in pots. Tea breaks are quiet, many doing crossword puzzles or discussing fishing or a television programme. Many visitors expect us to be having aesthetic discussions or Japanese tea ceremony, but this is not the nature of a workshop. We have many overseas visitors who make the pilgrimage to the Leach Pottery because of Bernard's book, written in 1939. We shudder to think what their expectations of the pottery are, and often feel we do not live up to their image of the workshop ... after all the image is in the pots! We abandoned the open house policy about ten years ago because we found that most of the tourists we were attracting were not really interested, only curious, and none of our potters like to give demonstrations at that level. Instead we try never to turn away a potter or a student, or someone really interested. One of our potters gets off his wheel and takes them around the workshop and answers their questions.

We are interested in the development of our potters, but the workshop approach is to put the 'good pot' first and the potter must find his own development in the pursuit of it.

I was hesitant to write about the pottery when I was first asked because I was too much in it, and I felt it wouldn't stand still long enough to be recorded. It's like the shifting sand of the beach which is never the same as the day before, but is always there.

CHAPTER 5 Free Rein at St Ives

In spite of the many difficulties and disappointments in Janet and Bernard's relationship, they remained supportive of one another in their working partnership. They did what they could to stay kind to each other, and were determined to make the best of their marriage which, after all, was the third for each of them, even once they had acknowledged they were really better off living apart. David Whiting remembered Janet telling him that in an attempt to please Bernard, she had taken him, slightly against his will, to watch a Marilyn Monroe film at the cinema down in St Ives, explaining, 'I thought it would do him good.'

Janet said that one of her duties as Bernard aged was to get him to his speaking engagements, 'in a clean shirt, on time, calm, not hassled, and away from the lionising women until after the lecture.'[48] Janet's residual but genuine warmth of feeling towards Bernard was exposed in a letter tape to Shigeyoshi Ichino, in which she spoke extremely proudly, describing in great detail how beautiful he had looked in his top hat and tails as he travelled by taxi to receive his CBE at Buckingham Palace.

In *Beyond East and West*, published in 1978, the year before he died, Bernard wrote, 'I wish to make it clear how Janet has contributed to the organisation and development of the Pottery. David did a great deal in this respect in his earlier long period, but … Janet has contributed to its further development and has supported my work with full loyalty as a potter. Her best pots have always contained a reflection of her own true character. It is my hope that she will continue to run our workshop at St Ives in her own style and in her own name.'[49]

Janet visited her parents in Texas for a few weeks in 1977, to be with them during her father's final illness. While she was away, Bill Marshall resigned from his job as foreman to set up his own workshop and kiln in Lelant. When Janet returned to St Ives and discovered that Bill had gone, she wrote to Byron Temple to offer him the foreman's position. Byron, who had worked at the pottery nearly twenty years earlier, accepted her offer and the following year travelled from Kentucky to St Ives to take up the appointment, but it didn't work out. He felt too much had changed since he was last there, and disputes arose between him and both Bernard and Janet, which in turn caused disagreements between the two of them. Before long Byron returned to America, leaving the pottery once more without a foreman.

After Bernard's death in 1979, and with no foreman's needs to consider, the pottery was effectively Janet's to run entirely as she pleased, so she was now able to focus on her own work and her creativity flourished. As well as making her own individual pots in her workshop, she continued to run the main pottery, but wound down the standard-ware output. Janet felt that as the standard-ware had initially been Bernard and David's product it should be phased out once Bernard was no longer there to oversee it. Janet scaled down the workforce by recruiting no replacements for those who left to establish their own potteries. By 1981 only Trevor Corser and Jason Wason remained.

Janet was sixty-three by then, and wanted someone to stay at the pottery working part time for her, to help fill and fire the large eight-burner gas kiln, which had replaced the older oil-fired kiln. The climbing kiln had not been fired for about six years as the smoke from it had begun to threaten the peace in the neighbourhood, where new housing estates had been built on the fields all the way up the hill from the town, and now surrounded the pottery. Although the gas-fuelled kiln was large, it was much smaller than the climbing kiln and could reach maturing temperature a lot quicker, and was cleaner and much easier to control. Janet said that firing the climbing kiln had involved a great deal of hard work before and during the long firing, including preparing the wood for side-stoking the individual chambers, and carefully checking glaze test rings for temperature and firing maturity.

With the newer, gas-fired, single-chamber kiln, as long as the workshop door was kept open it was possible to hear if all was well, by listening from the throwing room a few feet away, as its low roar intensified with the rising temperature. It was perfectly possible to throw pots and attend to the gas kiln at the same time. The kiln temperature needed to be checked at regular short intervals, using a pyrometer and cones, the gas pressure had to be adjusted and the damper had to be put in for reduction as the temperature approached a thousand degrees, but that was all that was required during the eleven-hour firing, which eventually took it up to 1280°C.

Of the two remaining potters in the main workshop, Jason left to set up his own pottery near St Just, while Trevor, who lived nearby in the centre of St Ives, was happy to stay at the Leach workshop working two days a week for Janet, and using the pottery facilities for his own work on the other days. It was around this time that Janet bought her small gas-fired Laser kiln which she installed on the covered verandah outside her workshop. Here she continued her experimental firings on smaller pots. The remaining sixteen years of her life represented her productive heyday. She was now able to work whenever she wanted, free to experiment as she liked with clay bodies, glazes and firings.

The pots she made around this time were exhibited in Britain, Europe, America and Japan where she had solo exhibitions in Tokyo and Okayama, two in Kobe and five in Osaka. She also had a solo travelling exhibition which was shown in five cities in northern Japan. Her pots are included in several major international collections.

Among Janet's closest friends in St Ives were Pam Hodin, Mary 'Boots' Redgrave, Kathy Watkins and Barbara Hepworth. In 1965 Boots went into partnership with Janet in running the New Craftsman in St Ives, which Janet had opened in 1962. It was one of the first galleries in the South West where it was possible to buy a Lucie Rie or Hans Coper pot. Kathy Watkins ran the Penwith Gallery from the 1960s until her death in 2013, and was Janet's last surviving friend of a roughly similar generation to her own. The Penwith Gallery was the major gallery in St Ives and the surrounding area, before being eclipsed by the arrival of Tate St Ives in 1993. Barbara Hepworth had been a founder member of the Penwith along with her husband Ben Nicholson.

Janet had been impressed by Barbara's work when she first saw a photograph of her sculpture *Two Spheres* in a book by Herbert Read which she found in a Houston library while working for the Willkies as a teenager. As an

Janet and Barbara Hepworth in the garden of Trewyn Studio, St Ives

aspiring young sculptor Janet was particularly struck by this work of Barbara's and had never forgotten it. She couldn't possibly have imagined then that one day she would meet Barbara, they would become close friends, and that she would eventually bring a bronze edition of the *Two Spheres* home with her, to place under a mature laburnum tree beside the Stennack stream, in the garden opposite her workshop at Pottery Cottage, where she could see it through the glass of her workshop door every time she looked up from her wheel. It stayed there looking very strong, shaded by the laburnum for the rest of Janet's life.

Barbara and Janet spoke each night on the phone, Barbara from her home at Trewyn Studio, and Janet from Pottery Cottage, each sitting up in bed with a glass of whisky, smoking a cigarette. Then shockingly, in 1975, after just such a night-time phone call, Barbara's house caught fire and she was killed. She had recently been prescribed sleeping pills and was sleeping too deeply to wake when the fire started.

Barbara's death was a devastating blow for Janet who suddenly had to come to terms with living without her companionship and the laughter they had always enjoyed together, having shared a similar take on life. Her support as a kindred spirit had been very important to Janet in the sometimes unsympathetic world of St Ives. Janet was always grateful to Barbara for teaching her a great deal about 'being a professional woman', saying she didn't think she could have survived without her during her early years as a foreigner in Cornwall. Barbara's death was also an abrupt warning for Janet, alerting her to the dangers of smoking in bed and prompting her to get smoke alarms installed in Pottery Cottage, although not to forgo her bedtime whisky and cigarettes.

I don't know when Janet's relationship with whisky really began in earnest, but to her great credit no matter how much she had drunk, and by late afternoon that was often quite a lot, her character never changed at all. For some reason she was keen to make it absolutely clear that, as she told me, 'I'm not an alcoholic, I'm a drunkard!' Whatever she called herself, she was remarkably steady-natured whether or not she'd had a drink. Although her speech could become slurred, she was never in the least bit erratic and her mind and memory remained as sharp as ever. She was also alert and clear-headed each morning when I arrived at work. I admired this unusually even-natured characteristic of hers, and was very grateful for it too.

Janet received many visitors to the pottery, and in April 1984 HIH Prince Naruhito of Japan paid a visit. In 2017 his father Emperor Akihito announced his intention to abdicate from Japan's Chrysanthemum Throne in favour of his heir, Crown Prince Naruhito, who finally became Emperor of Japan on May 1st 2019.

Looking at this photograph of Janet and Prince Naruhito I can imagine that Janet had dressed carefully in clean clothes for his visit, but then, feeling shy, deciding at the last minute it might look more workmanlike to smear a little bit of porcelain onto her clean jumper. Although he is immaculately turned out, they look as shy as each other.

When Janet had first arrived at the Leach Pottery none of Bernard's pots were on public display, so over the following years she gradually collected around a hundred for this purpose. Bernard had given some of them to her as Christmas presents or for birthdays and, at least in the early days, as wedding anniversary presents, though as Janet remarked, 'that fell away a bit!'[50] Other pots of his she had saved from being deliberately smashed because they had cracked or even split wide open during the firing. These pots were glued to their shelves, and presented with their good sides showing. Janet had chosen all of them despite their firing flaws, for being otherwise very fine examples of Bernard's work.

One night in August 1995, the back of the wooden showroom was broken into and forty-three of these pots were stolen. A local detective inspector was invited to appear on the television programme *Crimewatch* to highlight the case. Janet said she had warned him against giving a public lecture on Bernard Leach, and told him, 'Don't even try; you'll only lay an egg.' Five months later most of these pots were recovered on the Isle of Dogs in London, and were returned to the pottery, after which two men were sentenced to six years in prison and a third to seven years. I can only assume this was not their first offence.

I first met Janet at the pottery in 1976. Over ten years later when she needed some assistance, and knowing I had worked with clay, she asked if I would come and help in her workshop, mixing clay and glazes, and rolling, cutting and assembling clay pieces shaped from her own cardboard templates into sizeable slab pots of her design which she adapted before adding feet or lugs and glazing them. For a short time I'd had a part-time job in an ill-fated cabbage crate factory in St Just, the owner angry and frustrated by machinery which kept breaking down, so I was only too happy to oblige.

One day when I was fetching something for Janet from a cupboard in her workshop, I found some small, very wonderful wood-fired pots, many with vestigial handles or lugs. They had clearly been made by her but I had never seen anything like them before. They were tucked away hidden in a dark corner behind a large biscuit-fired pot stamped by both Bernard and Hamada, and decorated with a 'Tree of Life'. I asked her about the little pots and she was taken aback and pleased that I was interested. She explained that someone in the workshop had laughed at them when she made them over ten years earlier, so she had stowed them away beyond ridicule. There were about twenty of them, in yellow clay, fired in Janet's 'Bizen' style, with patches of natural colour and surface encrustations. I got them all out and we talked about them for a long time. After checking them for firing cracks, we put them in the showroom where they were all very quickly sold. After this serendipitous discovery, Janet set to work to make more pots in the same style, firing them in her small Laser kiln.

Before these pots were unearthed Janet had never asked me for my opinion about her work, and nor had I offered it, but now she often asked me what I thought about a batch of work she had made the previous evening, and I was happy to discuss them with her. Just once a pot of hers worried me, and I asked her whether she thought it had maybe gone a bit too feral. The idea amused her, though I was genuinely concerned about it. Interestingly, this pot was bought by the art historian Dorris Kuyken-Schneider, Curator of Ceramics at the Boijmans van Beuningen Museum in Rotterdam.

After this I became more involved with Janet's firing processes. I made saggars for her from heavily grogged clay with circles cut out of the sides. She packed the saggars with pots which were then surrounded with wood in every state available, including sticks, chippings, shavings and sawdust, hard wood, soft wood and charcoal, as well as driftwood and seaweed from the beach which produced a slightly salt-fired effect. Sometimes she included chunks of wood which still had nails sticking out. Once, inexplicably to me, a nail ended up bonded and sunk into the wall of a pot after firing but the nail

head still held traces of its original striated texture. These firings produced surface flashes of red and black, and encrustations similar to the pots she had admired in traditional Japanese potteries.

Left to her own devices, with no critical eyes on her to judge her work before it was ready for exhibition, her production prospered and I was privileged to assist her during this fruitful time.

I also wrote out Janet's letters for her, sitting at the table surrounded by Bernard's and her own unique collection of historical pots from Korea, China and Japan, as well as modern pots by many renowned potters including Hamada, Bernard, Maria Martinez and Lucie Rie. Of course some of Janet's letters were to the gas board but many more were to her friends or contacts in the art world. Her dictation was impressive; reeled off quietly without any notes or corrections, it was always charming, meaningful and direct.

The biggest pot in the room was the beautiful and now famous Korean moon jar that Bernard had bought in Korea in 1935 and shipped back to Britain in an ornate wooden Korean chest which was bound with wide iron straps. A few years later, during the Second World War, he gave the moon jar to Lucie Rie for safekeeping. It remained with Lucie in London for the rest of her life.

In the early 1990s after suffering a series of strokes, Lucie developed heart problems which led to her being fitted with a heart pacemaker. When Janet heard about this she became seriously alarmed, imagining the pacemaker would keep Lucie alive artificially, caught up in a permanent state of suspended animation, and, as Janet put it, 'unable to die'. Janet was quite haunted by this gruesome possibility and told me seriously that she was thinking of having a tattoo put on her chest forbidding any such intervention for herself.

However in 1995 Lucie did die, and left the Korean moon jar to Janet in her will. When it was delivered to Pottery Cottage Janet was quite overwhelmed, elated by its presence. She had me position it so she could feast her eyes on it from either room of her downstairs flat. It stood on the same Korean chest that it had been packed in sixty years earlier for its journey to Britain. Now in Pottery Cottage it joined her much-treasured, ancient Tamba pot in her affections.

While we were dealing with her correspondence I got to know the moon jar very well in its new domestic surroundings, with its markedly misshapen belly where the two thrown halves were joined, its neck echoing its foot ring and its glazed surface covered all over with strange little blackened scratches.

When Janet died Boots Redgrave inherited everything from her, including the moon jar. A few days later, and to my astonishment, Boots gave the

Korean moon jar in Pottery Cottage
This picture of the moon jar perched on a stool in Janet's living room was a quick snap taken for probate after Janet's death. It now stands alone, over-zealously cleaned and looking rather cold but still magnificent, in a glass case in the British Museum.

moon jar to me. However, the next day she said she needed it back to raise cash for death duties. It was put up for auction at Bonham's and was sold for £380,000. When the winning bidder failed to pay it was finally sold to the British Museum for £120,000.

Comedy and Kindness

Janet's stories about her early life were often extremely entertaining. She was very comical when talking about her earliest memories of Texas, for example how the townspeople of Dallas thought themselves a cut above the local

farmers, until the farmers struck oil. Then, still in the depths of the Depression with its grinding poverty, anyone with a bit of land suddenly became so rich that they were buying their daughters a piano each while the town-dwellers looked on in envy.

One of Janet's spinster aunts was kept carefully cloistered at home near Grand Saline in preparation for looking after her parents in their old age. She was prevented from going out or mixing with anyone, and was only permitted to walk a short distance up the 'trail' to fetch the post from the mailman on his rounds. He was the only man ever to cross her path, and of course she married him and moved away.

Janet's speech was always Texan in accent and vocabulary, and after forty years in Cornwall she still referred to the 'railroad' and the 'mail truck'. The only attempted concession to British English I ever heard from her was a reference to 'cupboard gays'. One day, Boots found Janet watching Ascot on television and accused her of being a monarchist. Outraged by this slur, Janet told me, 'Sure I love to watch Ascot on TV, I'm an American for God's sakes!' She was urbane, a woman of the world, who was by nature sincere and courteous in both speech and manner but she would always speak frankly rather than prevaricate, and swear any way she liked for emphasis, although I never heard her swear at, nor about anybody.

Janet was full of great humour while describing the events of her life and the encounters she'd had, but I noticed that whenever we were discussing pots, while I often laughed, she never did. She took pottery absolutely seriously.

She never took any exercise and had very firm ideas about it. Once when I mentioned I'd walked somewhere she said nothing, but must have been mulling it over, because later that day she asked me in a serious voice if something was wrong, and why had I been walking. Boots told me that Janet thought walking was only done during a bout of depression or as a form of sport. In fact she found the thought of exercise so distasteful that Sumi, her black Labrador, used to be taken down to the New Craftsman in St Ives for a change of scenery before being sent back up to the pottery, in a taxi. Sumi can't have had any exercise at all because Janet kindly saved her the effort.

Sometimes I used to ride to work on my bike, along the lovely twelve-mile coast road between Botallack and St Ives, but Janet was so horrified when she found out that she immediately gave me her car. She had bashed the side in while reversing into some bollards in St Ives a few days earlier, and must have felt she would be better off without it. That was my first car, which I drove for years, long after Janet had died.

The Pottery Garden, Life and Death

The pottery garden was a riot of plants, animals, birds, insects and fish. In those days the kiln shed was open to the path by the stream and every year robins nested among its entrance timbers, while dozens of cheeping sparrows lined their nests in the eaves. Trevor and I regularly rescued hedgehogs that had fallen into the old climbing kiln's disused firing pit. This happened so often that eventually we fixed a ramp down into it so they could find their own way out. A sparrowhawk took to perching in a large bush, waiting for the opportunity to kill and eat collared doves that never seemed to take enough care. One day Trevor said he saw a mink bounding along the far bank of the stream. Almost hidden amongst the lush vegetation were productive damson trees and hazels. Wild strawberries lined the paths, and wood ear mushrooms grew on the branches of elder trees. We added them to soup cooked beside the workshop fireplace.

Amid all this verdure was a small round pond which had accidentally been blasted into being by a Second World War German bomber. Later on it was deliberately modified to be fed and drained by the Stennack stream. I saw a brown trout in it swimming against the flow.

Janet eyed the encroaching greenery with suspicion, convinced it was giving her asthma. She got me to attempt to tame it by mowing the grass and trimming hedges, starting with some topiary to her design. She wanted me to cut a tall shrub growing by her garden gate into the shape of a round-bellied pot with a narrow neck and a round top. It had to be trimmed to keep it in shape until it finally grew too tall and wide to reach in to clip.

As the 1990s progressed, as well as asthma, she began to be troubled by a painful leg which affected her quite badly, forcing her to cut down her time working on the wheel, and eventually to give up throwing altogether. When the pain got worse she turned to producing only slab pots which, as they diminished in size, seemed to become more and more exquisite. By her late seventies, which turned out to be the end of her life, Janet's pots were very small, often only six or seven inches tall, but they were livelier and more adventurous than ever.

By 1996 her liking for cigarettes and whisky and her total lack of exercise, now made worse by her bad leg, were starting to affect Janet's general health, but her interest in making pots never diminished. Early in 1997 she worked on a series of pots for a last exhibition, held at Austin Desmond Fine Art in Bloomsbury, London. All the pots were new, made especially for the exhibition. They were small, slabbed and gently paddled boxes or long-necked,

square or oval pots, all of bare black clay with a single white glaze pour on each side. They were the culmination of her life's work and all of them were sold.

Such productive drive in the last months of her life was evidence of Janet's extraordinary commitment to her work. Her last pots were produced while she was suffering from the effects of low blood pressure and accompanying lack of energy. She became increasingly unwell, and twice that year she had to spend a few days in hospital. Janet never fully recovered her strength, and on the morning of 12 September 1997 she died in Pottery Cottage at the age of seventy-nine.

Slabbed pots from Janet's last completed batch, h. 5–18cm

Postscript

A year after Janet died, the Leach Pottery was designated a Grade Two listed site by English Heritage. Seven years later it was sold to the local council and a great deal of building work was done. Nearly three years after that it was reopened as a museum, with the addition of new working facilities for young potters. Among the inevitable compromises in the redesign of the plot was the loss of the pottery garden which was cleared away and replaced by a gravel yard, which for reasons of accessibility and utility was surrounded by a walkway, the new workshop and a car park.

Shortly after the renovation was completed, I was working at the pottery once more, when I heard that during the building work a gun had been discovered on the premises and had been handed in to the police. The talk about a gun puzzled me, until I remembered that for years while Trevor and I were working down in the workshop, and later when Amanda Brier joined us, if

Janet's wheel

we needed any general, non-pottery tools, we would lift a wooden box down from a shelf above one of the wheels, open the lid, remove a hammer, an oil can and a gun from the top, find the screwdriver, spanner or whatever was needed underneath, then we'd put it all back again, gun included, before putting the box back up on the shelf. It doesn't seem to have occurred to any of us to question why there was a gun in the toolbox, and I don't remember any discussion about whose it was.

Nobody else employed at the newly-reopened pottery had ever met Janet, but in the years after her death she had acquired an ill-founded reputation as something of a hard character, and the gun was assumed to have been hers. I don't know who owned the gun, maybe it was Janet's, maybe not. I very much doubt it was hers because she wasn't careless like that.

She did however have a flick knife, or as she called it a 'switchblade', which she kept next to her wheel as one of her essential pottery tools. This was the knife her grandfather had given her over seventy years earlier when she was a small child in Texas, the same knife with which she had begun to carve out her career as an artist.

Janet's water pot and tools

PLATES

Bizen-inspired pot, h. 11cm

Bizen-inspired pot, h. 8cm ·

Bizen-inspired pot, h. 7cm

Bizen-inspired pot, h. 7cm

Bizen-inspired pot, h. 7cm

Bizen-inspired pot, h. 20cm

Bizen-inspired pot, h. 23cm

Bizen-inspired pot, h. 18cm

Stoneware small pot, wood fired with a grey and rust surface,
with green ash and black ash splashes, h. 9cm, c. 1990
Image courtesy of Maak Contemporary Ceramics

Black stoneware bottle, thrown, white glaze pour and dip, h. 44cm, c.1980
Collection and photograph Mike Sanderson

Red stoneware bottle, thrown, white glaze pour and dip, h. 41cm, c.1980
Collection and photograph Mike Sanderson

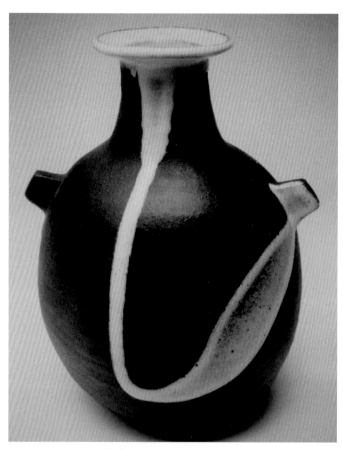

Black stoneware bottle, thrown,
white glaze pour and dip, h. c.17cm, c.1980

Black stoneware vase, thrown, white glaze pour and interior, h. 15.5cm, c.1980
Collection of Philip Mykytiuk. Photograph David Binch

Black stoneware pot, thrown, white glaze pours and lip, h. 25cm, c.1980
Collection of Philip Mykytiuk. Photograph David Binch

Black stoneware pot, thrown, white glaze and neck, h. 25.5cm, c.1979
Collection of Philip Mykytiuk. Photograph David Binch

Black stoneware pot, thrown, black glaze pour and dip, h. 27.5cm, c.1980
Collection of Philip Mykytiuk. Photograph David Binch

Red stoneware pot, thrown and faceted, limestone glaze, h. 20.5cm, c.1979
Collection of Philip Mykytiuk. Photograph David Binch

Red stoneware pot, thrown, striated and slipped, h. c.18cm, c.1979
Estate of J.P. Hodin. Photograph Mike Sanderson

Black stoneware lidded pot, thrown and facetted,
black glazed lid, h. 15.5cm, c.1978
Collection of Philip Mykytiuk. Photograph David Binch

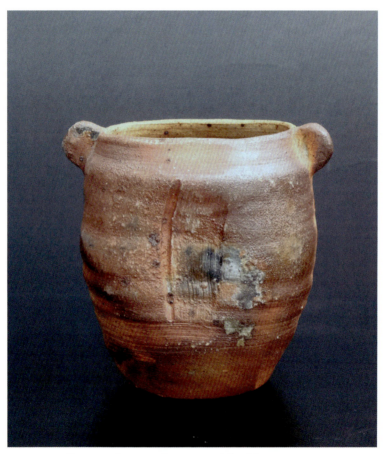

Yellow porcelain pot, thrown, wood-fired, h. 12cm, c.1978
Collection of J.P. Hodin. Photograph Mike Sanderson

Red stoneware pot, thrown, white pours and dip, mid–late 1980s

Black stoneware bottle, thrown, cut-sided,
black glazed lip, mid–late 1980s

Black stoneware, slabbed pot, white glaze pour, h. 10cm, 1996
Estate of J.P. Hodin. Photograph Mike Sanderson

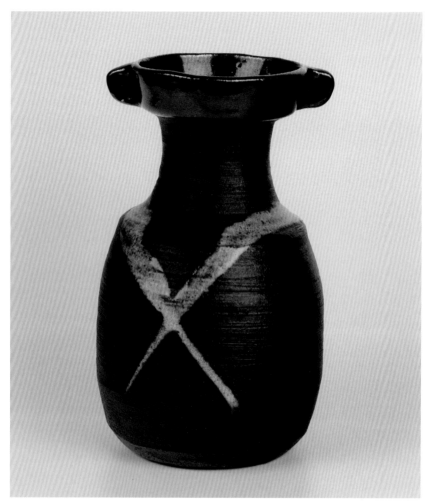

Black stoneware pot, thrown, white glaze pours,
black glaze interior, h. 20.5cm, c.1980
Collection of Philip Mykytiuk. Photograph David Binch

Black stoneware pot, thrown, white glaze pour and dip, h. 25cm, c.1980
Collection of Philip Mykytiuk. Photograph David Binch

Red stoneware trough, white glaze pour, 14cm, c.1990

Stoneware vase, brown body with a white glaze splash; date unknown
Photograph by David Westwood

Stoneware vase, dark brown body with a white glaze splash, h. 17cm, c. 1990
Image courtesy of Maak Contemporary Ceramics

Stoneware vessel, dark brown body with a white glaze, h. 26cm, c. 1990
Image courtesy of Maak Contemporary Ceramics

Stoneware vessel, dark brown body with a white glaze; h. 10cm, c. 1990
Image courtesy of Maak Contemporary Ceramics

Stoneware square bottle, matt black body,
a white glaze and a shiny black glaze, h. 20cm, c. 1990
Image courtesy of Maak Contemporary Ceramics

Stoneware vase, dark brown body with dark iron speckle,
with mottled white and brown splashes, h. 32cm, c. 1990
Image courtesy of Maak Contemporary Ceramics

Stoneware vase, black body with strong white splashes, h. 21cm, c. 1990
Image courtesy of Maak Contemporary Ceramics

Stoneware bottle, dark brown body with white splash glaze, h. 9cm, c. 1995
Image courtesy of Maak Contemporary Ceramics

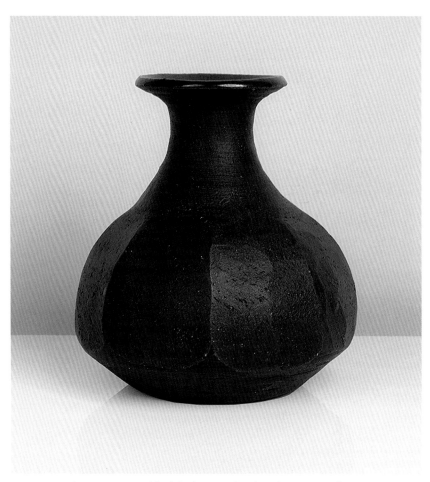

Stoneware vase, black body tenmoku glazed interior and rim,
h. 14cm, date unknown
Image courtesy of Maak Contemporary Ceramics

Stoneware vase with lugs, brown body with fire markings and brown,
black and green ash glazes with ash deposits, h. 14cm, date unknown
Image courtesy of Maak Contemporary Ceramics

Stoneware monumental vessel, brown body
with dark brown glaze splashes, h. 35cm, c. 1990
Image courtesy of Maak Contemporary Ceramics

Stoneware charger, brown body with white and
brown trailed glazes, diameter 48cm, c. 1970
Image courtesy of Maak Contemporary Ceramics

Stoneware charger, brown body with delicate iron speckle, a white splash
crossed with iron trailed splashes, the rim and underside
with tenmoku glaze, diameter 48cm, date unknown
Image courtesy of Maak Contemporary Ceramics

Stoneware vessel, brown body with fire marking
with green and black ash deposits, h. 16cm, date unknown
Image courtesy of Maak Contemporary Ceramics

Stoneware bottle vase, brown body with cream and black
fire markings and a bubbled surface, h. 15cm, c. 1990
Image courtesy of Maak Contemporary Ceramics

Porcelain bottle with lugs, pale celadon glazed body
with iron splashes, h. 20cm, c. 1973
Image courtesy of Maak Contemporary Ceramics

Janet Leach's Clays and Glazes

Black clay body
Doble's St Agnes stoneware with added black iron oxide and manganese dioxide

Red clay body
Doble's St Agnes stoneware with added red iron

Saggar-fired 'Bizen-style' body
Doble's porcelain with added yellow ball clay

White porcelain for slab work
Doble's porcelain with added molochite

White glaze
Leach Pottery standard white glaze '24', with addition of 10 per cent bone ash

Black glaze
Leach Pottery standard tenmoku glaze with added manganese dioxide

Limestone and ash glazes
Mixtures of limestone, whiting, ash, feldspar, clay

Celadon glaze
Standard Leach Pottery Yin Ching

Thrown pots
All made on a Korean kick wheel

Slab pots
Rolled out, cut and assembled. Lugs or feet added later

Bibliography and Endnotes

Bibliography

1. Janet Leach interviewed at Leach Pottery, late 1980s. [Home-made recording]
2. Application for Guggenheim Fellowship. Janet Darnell, 1954
3. *Beyond East and West* Bernard Leach. Faber and Faber, 1978
4. Janet Leach lecture. Gaige Auditorium, Rhode Island College, 1982. [Home-made recording]
5. Janet Darnell's diary, 1954/1955 [loose-leaf, pages unnumbered, rarely dated]
6. Correspondence between Janet Darnell/Leach and Bernard Leach
7. *A Potter in Japan* Bernard Leach. Faber and Faber, 1960
8. Part of Janet Leach's Preface to *Hamada: Potter* Bernard Leach. Kodansha International, 1975
9. *Bernard Leach, Hamada and their Circle* Tony Birks and Cornelia Wingfield Digby. Phaidon, 1990
10. *The Dark Monarch* (2nd edition) Sven Berlin. Finishing Publications, 2009

Endnotes

1. Janet Leach lecture. Gaige Auditorium, Rhode Island College, 1982. [Home-made recording]
2. Janet Leach interviewed at Leach Pottery, late 1980s. [Home-made recording]
3. *Ibid*
4. Janet Leach lecture. Gaige Auditorium, Rhode Island College, 1982. [Home-made recording]
5. Janet Leach interviewed at Leach Pottery, late 1980s. [Home-made recording]
6. *Ibid*
7. Janet Leach lecture. Gaige Auditorium, Rhode Island College, 1982. [Home-made recording]
8. *Ibid*
9. *Ibid*
10. *Beyond East and West* Bernard Leach. Faber and Faber, 1978, p245
11. Janet Leach lecture. Gaige Auditorium, Rhode Island College, 1982. [Home-made recording]
12. Janet Darnell's diary, 1954/1955 [loose-leaf, pages unnumbered, rarely dated]
13. *Ibid*
14. *Ibid*
15. *Ibid*
16. *Ibid*
17. *Ibid*
18. *Ibid*
19. *Ibid*
20. *Ibid*
21. *Ibid*
22. *Ibid*
23. *Ibid*
24. Janet Leach lecture. Gaige Auditorium, Rhode Island College, 1982. [Home-made recording]
25. Janet Darnell's diary, 1954/1955 [loose-leaf, pages unnumbered, rarely dated]
26. *Ibid*
27. *Beyond East and West* Bernard Leach. Faber and Faber, 1978, p252
28. Correspondence between Janet Darnell/Leach and Bernard Leach
29. *Ibid*
30. *Beyond East and West* Bernard Leach. Faber and Faber, 1978, p254
31. Correspondence between Janet Darnell/Leach and Bernard Leach
32. *Beyond East and West* Bernard Leach. Faber and Faber, 1978, p254

33. *Ibid*

34. Correspondence between Janet Darnell/ Leach and Bernard Leach

35. Janet Leach lecture. Gaige Auditorium, Rhode Island College, 1982. [Home-made recording]

36. *A Potter in Japan* Bernard Leach. Faber and Faber, 1960, p235

37. *Beyond East and West* Bernard Leach. Faber and Faber, 1978, p257

38. Correspondence between Janet Darnell/ Leach and Bernard Leach

39. *Ibid*

40. Application for Guggenheim Fellowship. Janet Darnell, 1954

41. Correspondence between Janet Darnell/ Leach and Bernard Leach

42. Janet Leach lecture. Gaige Auditorium, Rhode Island College, 1982. [Home-made recording]

43. Correspondence between Janet Darnell/ Leach and Bernard Leach

44. *Ibid*

45. *Bernard Leach, Hamada and their Circle* Tony Birks and Cornelia Wingfield Digby. Phaidon, 1990, p9

46. Correspondence between Janet Darnell/ Leach and Bernard Leach

47. *The Dark Monarch* (2nd edition) Sven Berlin. Finishing Publications, 2009, p34

48. Janet Leach interviewed at Leach Pottery, late 1980s. [Home-made recording]

49. *Beyond East and West* Bernard Leach. Faber and Faber, 1978

50. Janet Leach interviewed at Leach Pottery, late 1980s. [Home-made recording]

Glossary

Celadon
Iron glaze. Usually semi-translucent pale green, blue, or yellow/grey

Foot ring
Base of bowls etc. the result of trimming away excess clay

Oxidation firing
Firing with unhindered supply of oxygen

Reduction firing
Firing where oxygen is limited sometime after 950 centigrade, forcing the flame to draw oxygen from the clay body and glaze, producing subtle colour changes

Saggar
Fired clay container for pots in the kiln, to protect glazed pots from flame and ash or alternatively to concentrate solid fuels around unglazed pots

Slip
A slurry of clay and water, used for decoration prior to firing

Slip trailer
Device for applying lines of decorative slip to a pot prior to firing

Turning
Trimming excess clay from a leather-hard pot or bowl after throwing

Acknowledgements

I have been given a huge amount of help in getting this book to completion. I am particularly grateful to Mike Sanderson who has worked on the layout with his specialist skills and extremely good grace. Many thanks are also due to Marty Gross and Lissa Mateus of Marty Gross Film Productions in Toronto, who did a beautiful job restoring and digitising Janet's photographs of Japan from 1954 and 1955. Marty has been a great help with his general and specialist knowledge of Japan. I am so grateful to friend and potter Jeff Oestreich who let me in on some of his warm and funny stories of time he spent with Janet fifty years ago. Many thanks also to my dear and erudite friend, poet and author Elizabeth Cook who suggested I read a history of Black Mountain College, which happily I did. I'm much obliged to the late Simon Olding and to Greta Bertram of the Crafts Study Centre, UCA, Farnham, for their permission as copyright holders of Janet's writings. The material Janet gave to me is now held in their collections. I'm also very grateful to art critic, curator, writer and friend of Janet's, David Whiting, for his support, and his heartfelt foreword which honours Janet, adds depth to her story and goes a long way to keeping her memory alive and well.

I am grateful to Philip Mykytiuk for lending me photographs of Janet's pots, and to J.P. Hodin's estate for lending me pots of Janet's to photograph. Thanks again to Mike Sanderson and to David Binch for photographing pots, to Heini Schneebeli for the photograph of Janet on page 7, and to David Westwood for his photograph on page 151. Many thanks to Ben Boswell for his kind permission to use the image on the frontispiece.

Special thanks to Maak Contemporary Ceramics for providing extra images for the plate section (www.maaklondon.com) and my sincere gratitude to Lucy Duckworth, Publishing Director at Unicorn Publishing, for seeking out and acquiring these extra photographs and for all her care from the first cup of tea to completion of this book.

I have tried to contact all owners and photographers whose works are reproduced here but where I have been unable to identify them to give them credit I offer my apologies. The square format black and white photographs of Japan in the mid-1950s were all taken by Janet herself.

Index

Page numbers in *italics* refer to photographs.

About the Author

Joanna Wason (née Griffiths) was born in 1952 in Berlin, where her father worked in Cold War intelligence. According to her mother, 'Stalin was being a bit of a nuisance,' so she took Joanna and her brothers back to Devon. In her early twenties Joanna moved with her young family to the far west of Cornwall where she had various jobs, including making sculptures to commission. In 1988 Janet Leach employed her as her workshop assistant at the Leach Pottery in St Ives. After Janet's death in 1997, Joanna stayed at the Leach Pottery where she made her own individual pots for the next ten years. She still works part-time at the Leach Gallery but now makes her pots in a caravan workshop near St Just.